IMAGES
of America

RIVERVIEW
AMUSEMENT PARK

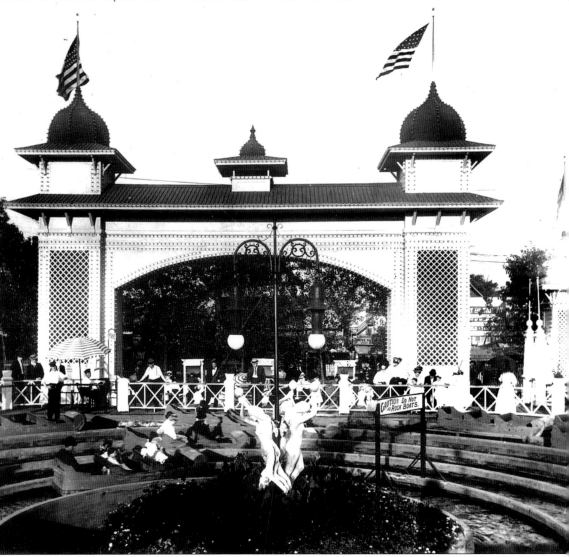

Millions of people passed through these gates for years seeking entertainment and relief from their every day lives. Their troubles were forgotten when they came to Riverview—the world's largest amusement park. (Courtesy of Schmidt Collection.)

IMAGES
of America

RIVERVIEW
AMUSEMENT PARK

Dolores Haugh

ARCADIA
PUBLISHING

Published by Arcadia Publishing
Charleston, South Carolina

Printed in the United States of America

Library of Congress Catalog Card Number: 2004109459

For all general information contact Arcadia Publishing at:
Telephone 843-853-2070
Fax 843-853-0044
E-mail sales@arcadiapublishing.com
For customer service and orders:
Toll-Free 1-888-313-2665

Visit us on the Internet at www.arcadiapublishing.com

This book is dedicated to my parents who took me to Riverview to share its fun and laughter, and to the hundreds of people who loved the park and shared that love with me.

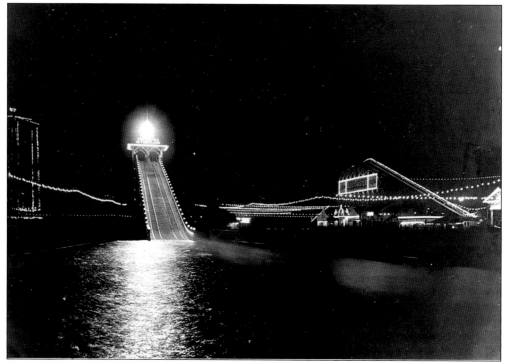

Over a thousand new electric lights outlined the rides at Riverview in 1908. The Chutes was always a highlight of the park. (Courtesy of Cleary Collection.)

CONTENTS

ACKNOWLEDGMENTS

Riverview has been a part of my life. I went there when I was a little girl and as a teenager. Later as a journalist, writing about the closing of the park, I decided to write a book about Riverview. It has taken almost a lifetime to do this.

The early park history was not known, especially the old attractions and rides. It was only through the generosity of the Schmidt family that early park clippings and photographs were shared.

Interviews with long-time employees produced more information. An exhaustive search of the park office after Riverview was sold uncovered still more facts. Luckily we rescued old files only days before vandals burned everything.

It took years to sort all of this material but management had not thrown anything away. Every memo, letter, catalog, blueprint, contract, and manual was kept.

Meeting members of the International Association of Amusement Parks and the Philadelphia Toboggan Company, a ride manufacturer, brought more facts to light.

Space does not allow the listing of all the people interviewed, sources of information, or use of all research material. To all who have preserved Riverview and shared its happy memories I give my heartfelt thanks and humbly dedicate this book to them.

INTRODUCTION

"Lets Go to Riverview"—the world's largest amusement park. This invitation to fun was echoed in Chicago for 63 years.

The story begins in the only grove within the city limits on the northwest side of Chicago between Roscoe Street, Belmont, and Western Avenues. Its western boundary was the Chicago River, whose flow had been reversed in 1900.

The wooded area was known as Sharpshooters Park as veterans from the Franco–Prussian War gathered there every Sunday for rifle practice. One member was William Schmidt, a wealthy baker who bought the 22 acres. For three generations the Schmidts owned the land.

When wives complained, the groves were opened to family members. Soon outside organizations begged to rent the groves for their own picnics. The rifle practice stopped. Picnic crowds ranged from 5,000 to 35,000.

William's son, George, was attracted by the new amusement park industry. He persuaded his father to lease six acres of the property for an amusement center. He and his father added three partners from the East Coast amusement park syndicate. Riverview Sharpshooters Park Company opened the pioneer park on July 3, 1904.

By 1910 the park had expanded, decreasing the groves and extending the attractions. What began as a six-acre park with three rides grew to 140 acres with more than 100 attractions. It was the largest amusement park in the world. It was the first to combine a natural park with amusement features.

Concessions were brought in and concessionaires paid a percentage of gross receipts to management. Concessionaires were also responsible for their own maintenance, insurance, and employees. Some rides were purchased, others invented or improved.

Riverview rides brought in customers looking for a thrill, but rides had to be safe. Roller coaster safety devices were invented at Riverview. Its low insurance rate and outstanding safety record proved it to be one of the safest parks in America. Almost every year a new ride would be introduced to bring back the customers. Top quality side shows and specialty acts kept the park a place for family fun. Competitions, contests, ethnic celebrations, political rallies, top bands, and new inventions were introduced at Riverview—capturing the interest of a changing public.

People from all walks of life found an opportunity to mix with others at Riverview. Politicians made a day at the park part of their campaigns, from Teddy Roosevelt to Robert Kennedy. A feeling of camaraderie was shared by all, and the music and food put everyone in a receptive mood.

Celebrities from Tom Mix to Walt Disney worked at the park. Others began their careers at Riverview and made a visit to the park a "must" when entertaining in Chicago. This landmark attracted tourists from all over the world.

People of almost every nationality came to the park for the park's ethnic celebrations, drawing thousands to the event. Exhibitions introduced new inventions: electricity, sound,

moving pictures, automobiles, planes, and later, atomic exhibits. Side shows brought actors, singers, dancers, and a freak show to the park. Every form of entertainment was there: a roller skating rink, dance hall, golf course, motorcycle races, Mardi Gras parade, Tournament of Music, baton twirling contests. Riverview kept in step with progress.

Children loved Riverview. Two Kiddylands featuring appropriately sized rides were successful family attractions. Special days were even set aside for school children and Chicago Mayor William Thompson closed schools and paid the admission and ride fees for the city's children. Hundreds of newspaper carriers flooded the park one day a year. Various industries took over the park for a full day or treated employees with rides and admission. United Charities held its annual Riverview Rambles fund drive at the park raising thousands of dollars for charity.

Riverview was exciting, educational, innovative, and financially successful. As a pioneer park, and continuing throughout its existence, Riverview set high standards. Its reputation guaranteed membership and leadership in the International Association of Amusement Parks.

It survived union problems, prohibition, competition, the Great Depression, two World Wars, and a near-killing World's Fair. When it closed on October 3, 1967 it produced seven million dollars for its stockholders. It was mourned by the public and its employees.

Memories of Riverview relive the fun.

Let's Go To Riverview!

One

SHARPSHOOTERS PARK

Sharpshooters Park was located on the banks of the Chicago River between Belmont Avenue and Roscoe Street, on Western Avenue, on the northwest side of Chicago. It began in 1879.

German veterans from the Franco-Prussian War, who served in Fredrich the Great's Jaeger Rifle Corps, held target practice there every Sunday afternoon. Though small animals and deer still were in the woods, they used paper targets, toasting winners with steins of beer. They formed the Nord Chicago Schultzen Verein. Legend states the wives complained about being left in the hot city with the children. Soon families packed picnic baskets and went to the park. The shaded area had benches, tables, and free band concerts. Other organizations begged to rent the park. Rifle practice was discontinued, though rifle ranges and shooting galleries (with real bullets) became a permanent part of Riverview.

The 22 acres of land were purchased by William Schmidt after he sold his Sedgewick Street Bakery and his invention of a soda cracker to the National Biscuit Company in 1903. This financed his real estate investments.

The park flourished as the work on reversing the river and the Western Avenue Bridge were near completion. There were 500 miles of streetcar tracks crisscrossing the city, making public access to the park possible from every point in Chicago for 5 cents.

Almost every German society had picnics at Sharpshooters Park. Beer gardens and small restaurants were soon added. Music, parades, band competition, political rallies, games, and shows kept the groves a lively center for cultural entertainment.

It was William's son, George, who envisioned an amusement park as part of the grove—an added source of income.

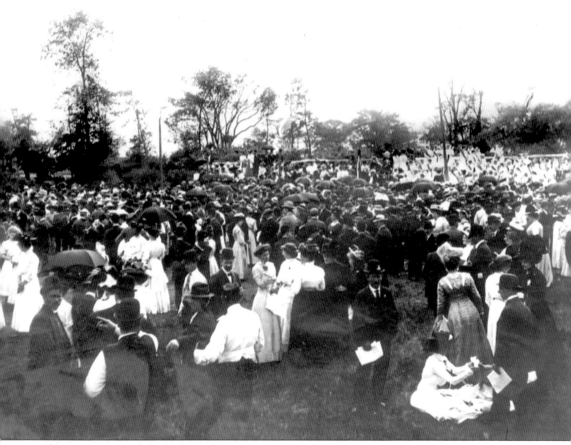

The groves provided shade and a picture-perfect picnic area to spend time with friends and neighbors. The fee was minimal and band concerts provided a taste of culture to those attending. The land was purchased by William Schmidt and George Goldman and was known as Sharpshooters Park. When Riverview opened on July 3, 1904, the gates consisted of two towers and a wooden front fence plastered with life-sized billboards hawking the marvels of the park. The attendance on opening day was 32,000. Riverview's owners were famous for sending out free passes—700,000 a year. One old-time concessionaire said, "The philosophy was 'Get 'em inside the park and take all their money out of their jeans'." (Courtesy of Schmidt Collection.)

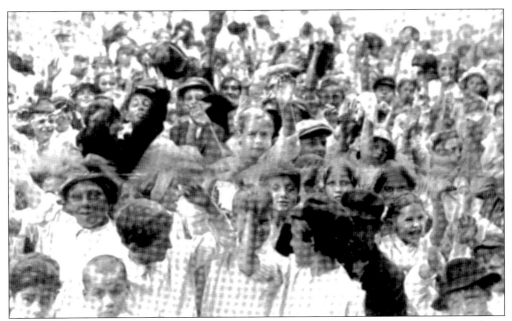

These happy kiddies are anxiously waiting for the picnic to begin. Remember they did not have a radio, television, or computer games. They played with marbles or jumped rope. A picnic was a very special event. Like many children, their moan at Sharpshooters Park was "There's nothing to do." (Courtesy of Cleary Collection.)

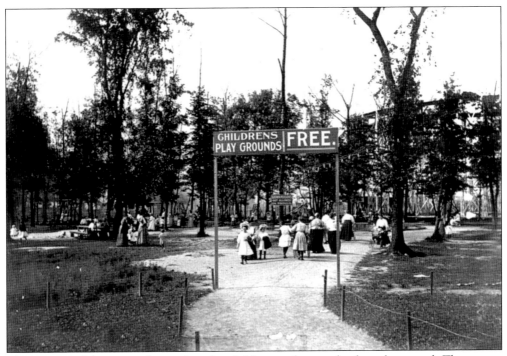

The owners of the groves listened to the children and opened a free playground. There were many things to do—slide, teeter-totter, wade in the pool. For a while everyone was content. But not for long. They wanted more! (Courtesy of Riverview Archives.)

The woods offered shade and space but as time went on other attractions were added. There was one large restaurant, a large band stand, the Rhine wine bar, five other bars, a large 100-foot by 50-foot dance hall (the largest in Cook County), ice houses, and chairs and benches. The latter are shown here. (Courtesy of Riverview Archives.)

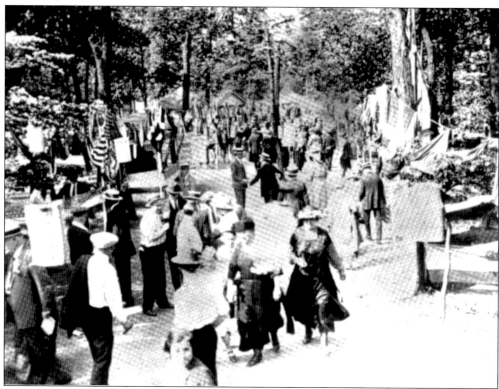

People came to the groves in droves. They had fun saving up for a special treat or packing a picnic basket. In 1904, there were 25 major picnics held, ranging in attendance from 5,000 to 35,000 people. The park was the most popular place in Chicago, used by almost every German society in the city. (Courtesy of Riverview Archives.)

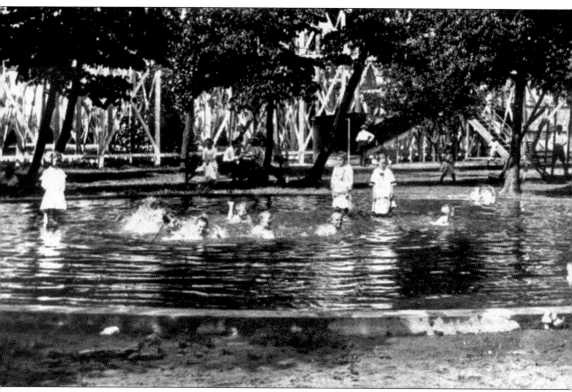

Regardless of the many added attractions, children still enjoyed the wading pool. In the background, people are shown eating at picnic tables. Other children are at the playground equipment. There was only a playground-type Merry-go-round in the groves. Here, a few mothers, fully clothed, join their children in the wading pool. (Courtesy of Riverview Archives.)

Music at the park was the main attraction for young and old. Bands of good reputation played in the groves where 5,000 free chairs welcomed patrons. A population of 100,000 people lived near the park, most of whom were from Germany. Song fests were very popular, as you can see from this photo. Almost every well-known bandmaster of the time played at the groves. (Courtesy of Riverview Archives.)

Bands were an integral part of entertainment at Sharpshooters Park, and the tradition continued at Riverview. Hundreds of bands performed in full dress uniforms. Prizes were awarded and audiences reveled in the patriotic tunes. American flags waved during the competitions and hundreds of parades marched through the park. Each year during Mardi Gras, band competition continued at Riverview. (Courtesy of Riverview Archives.)

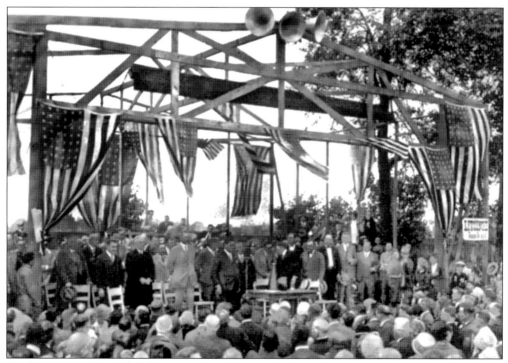

As Americanism was the theme at Sharpshooters Park, politicians came to greet the people, one-on-one, and all enjoyed food and music together. Democrats, Republicans, and other political parties distributed flags, buttons, and flyers along with descriptive speeches extolling their political platforms. It was a large captive audience. (Courtesy of Riverview Archives.)

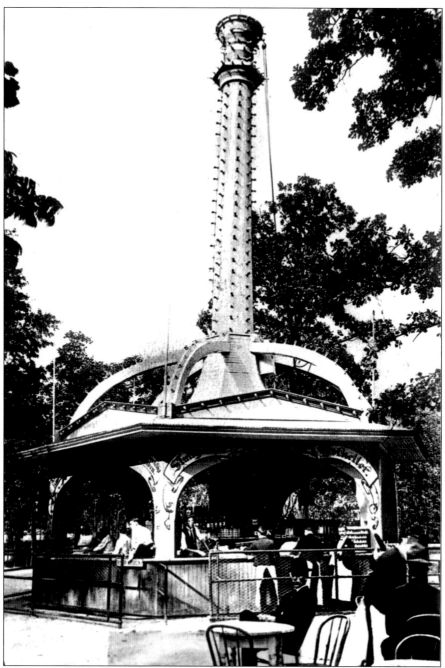

The Schwaben Verein, established in 1878, is one of the oldest German societies in existence. Each year, a Volkfest was held at Sharpshooters Park and later at Riverview. A permanent 65-foot "Tower of Fruit" remained part of the park. Each year fresh fruit was impaled on the tower for the two day celebration. In brightly colored costumes, 20,000 attended the park on German–American Day. The proclamation stated, "Friendships will be renewed when old friends come together and enjoy themselves. . ." This old world tradition began in Germany in 1816. (Courtesy of Cleary Collection.)

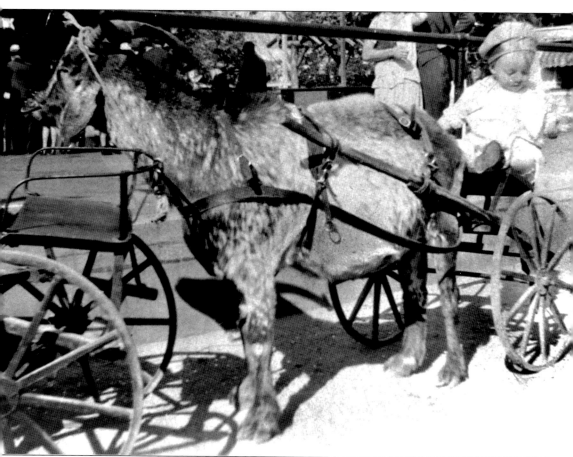

Ponies and goat carts were added to the groves for the enjoyment of picnickers. These were so popular that they offered rides for many summers. The need for speed eventually made them obsolete. The goats also ate ribbons from lady's hats, which contributed to their demise. They were originally in the main area but later moved to Kiddyland. (Courtesy of Waite Collection.)

Many concessions and games were part of the groves, such as soda pop and ice cream stands, shooting galleries, ball-throwing and cane games, and the ever-popular pony rides. The ponies were brought from the Shetland Isles and remained a popular attraction. They were "biters" but the trained handlers kept them busy going in circles. (Courtesy of Waite Collection.)

No one would believe long-time employee, Teddy Waite, when he said his miniature ponies were only 30 inches high and 42 inches long. At first, there were only 15 Shetland ponies but because the children loved them so much the number was increased to 38. One pony track was located along the Chutes, the other was near the Bowery area. (Courtesy of Waite Collection.)

Two

A PIONEER
AMUSEMENT PARK

Starting an amusement park proved to be a very difficult task. The public clamored for the entertainment and excitement introduced at the 1893 Columbian Exposition. It was a time of fairs, festivals, and expositions. People loved them. Sharpshooters Park had many advantages, including: a good location, guaranteed patrons (1,000,000 in this geographical location), picnic groves attracting thousands of people per season, transportation from every point in Chicago, plus river access. But internally there was a constant struggle for control.

The Schmidt family owned the 22 acres and it was William Schmidt's son, George, who saw a financial future in the new amusement park industry. He had attended many fairs and festivals in Europe and other U.S. locations during his summer vacations. (Copenhagen's Tivoli Park and Luna Park, N.Y. were patterns for Riverview.) He also became acquainted with Eastern amusement park officials and learned of the financial success of the new parks.

Chicago competition for Riverview was White City and San Souci Parks, both located on the south side of the city. There were other parks but they were too small to prove competitive. Riverview outlived them all.

Rides and attractions were being introduced at Luna Park, Coney Island, and other East Coast locations with great success. These concessions would bring new excitement to Chicago and more people to the parks.

George convinced his father to lease six acres of land fronting on Western Avenue to two Eastern representatives for $7,600 a year for ten years.

The park opened on July 3, 1904 to a public anticipating fun and recreation. There were only three rides owned by the Eastern representatives plus some other concessions, all under tents. Music was the main attraction—a proven winner at Sharpshooters Park. The use of electricity in illumination and spectacular shows attracted 32,000 patrons on opening day. All newspapers highlighted the park's opening and scheduled events, and gave bright reviews of the shows and acts. The park closed the 1904 season with a profit of $63,000 with only 70 days of operation. All concessionaires made money.

The Riverview Sharpshooters Park Company ("Sharpshooters Park" was dropped in 1905) was formed but competition became fierce when a fence between the two areas was removed. (The park had expanded to 140 acres and blossomed with 100 attractions by 1910.) When the 10-year lease expired, the Schmidt family gained full control of the park. The family kept Riverview one of the most successful in the industry despite economic trials and national disasters.

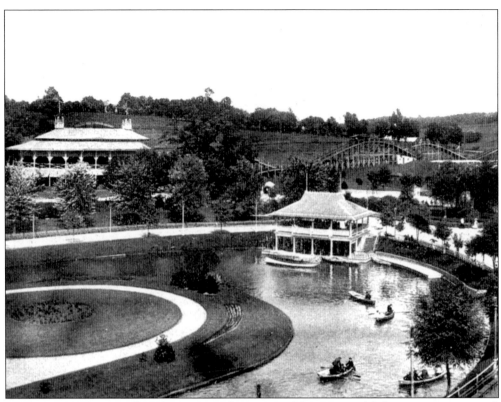

Amusement parks were flourishing across the country. Many successful features were repeated, such as use of ponds and lagoons, shows, specialty acts, and educational exhibits. They were copied from other parks, especially if they were money makers. Shown here is Chestnut Hill Park in Pennsylvania. Note the open spaces. Most early parks were located just inside the city limits. Space was always needed for the roller coasters. (Courtesy of Philadelphia Toboggan Co. Collection.)

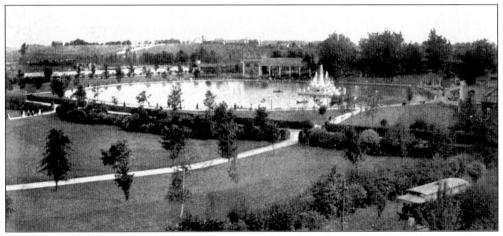

People arrived at Willow Grove Park, Pennsylvania, by trolley (lower right). Good transportation to any amusement park was essential to insuring its success. Water was an important part of amusement parks for boats and water rides. Other attractions were spaced among the landscaped areas. (Courtesy of Philadelphia Toboggan Co. Collection.)

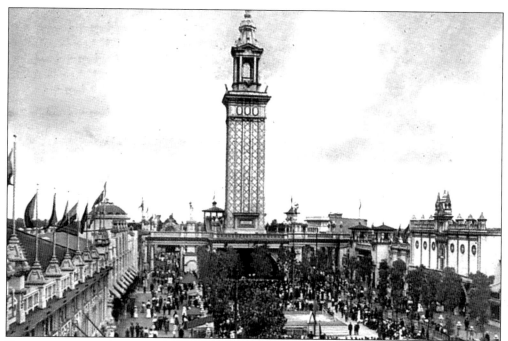

Two amusement parks were competitors of Riverview Sharpshooters Park. In 1903, White City (pictured above) opened at 63rd Street and South Parkway. Sans Souci Park was located at Cottage Grove and Midway Avenues. Small parks such as Limit, Ogden, and Shutes were not large enough for competition and lasted only a brief time. (Courtesy of Riverview Archives.)

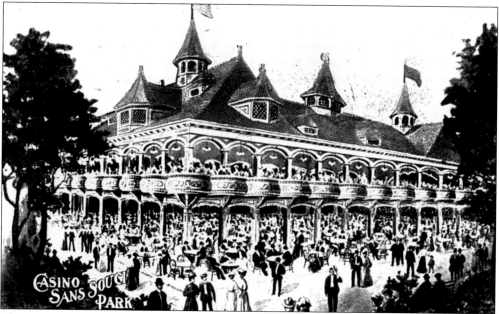

This postcard shows the architectural trend of the early parks. The use of turrets, mosques, domes, castles, and ornate trim predominated. Later, more traditionally styled Gothic pillars and arched windows were introduced. Bright colors, banners, and flags were dominant at every park. (Courtesy of Riverview Archives.)

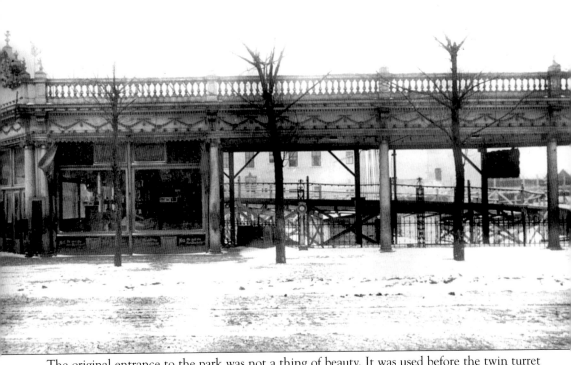

The original entrance to the park was not a thing of beauty. It was used before the twin turret gate and fence were built for the opening of the park. This structure extended along Western Avenue where William Schmidt had built small single family homes. The third gate was built in 1908 and welcomed patrons until the park closed. (Courtesy of Schmidt Collection.)

At the end of the gate area note the sign "High Class Entertainers Every Evening—Sunday Afternoons." The residents on Western Avenue had the benefit of the band music but also heard the screams of the people riding the Figure 8, seen in the background. As the park expanded these houses were razed. (Courtesy of Schmidt Collection.)

A brickyard was located near the park, providing a shortcut to Western Avenue. My grandmother took my mother to Riverview in the early days. They stayed late one night and my grandmother decided to take the shortcut. Riverview was a cultural center and everyone dressed up to go there. The women wore big broad brimmed hats held on with 12-inch hat pins. That night, my grandmother took out her hat pin for protection and marched across the yard with my mother. Luckily she did not have to use it! (Courtesy of Schmidt Collection.)

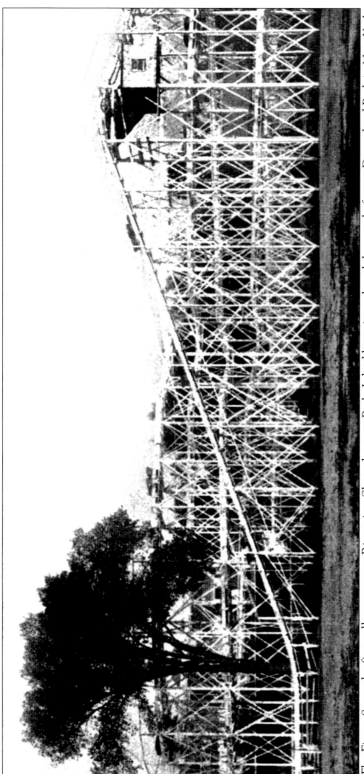

The Figure 8 was the first roller coaster at Riverview Sharpshooters Park. It had been introduced the year before at Dreamland Park in New York, proving to be a money maker. The ride had 12 cars on a trough-like track on a timber frame. A steam engine carried the cars up an incline and gravity brought riders back to the starting point. The cars were guided by side-friction wheels and propelled on four swivel casters. The coaster had a few mild four-foot drops on a short track and went six miles an hour. One rider described the ride as "exhilarating." The Figure 8 was the forerunner of the modern roller coaster. It cost $16,000 to build. (Courtesy of Philadelphia Toboggan Co. Collection.)

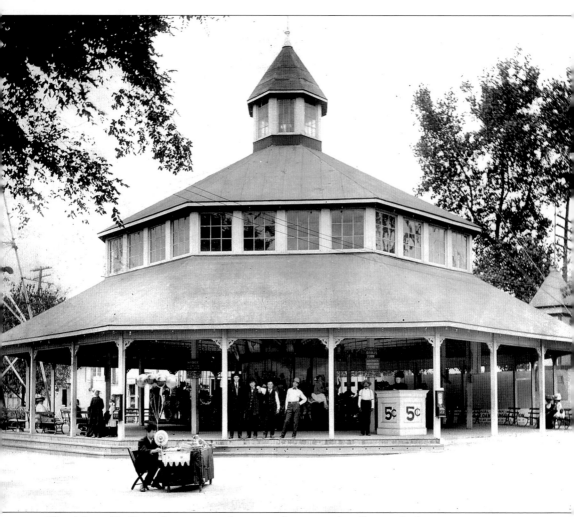

The Merry-Go-Round was second in popularity to the Figure 8. It was a concession at Riverview Sharpshooters Park owned by the Eastern group. The Morris Carousel was described by the owner as having "very handsome figures in an octagon pavilion 100 feet across and 45 feet high." The cost of a ride was 5 cents. The large Fairyland Carousel did not arrive until 1908. Note the balloons marking the glass etching souvenir booth in the foreground. (Courtesy of Schmidt Collection.)

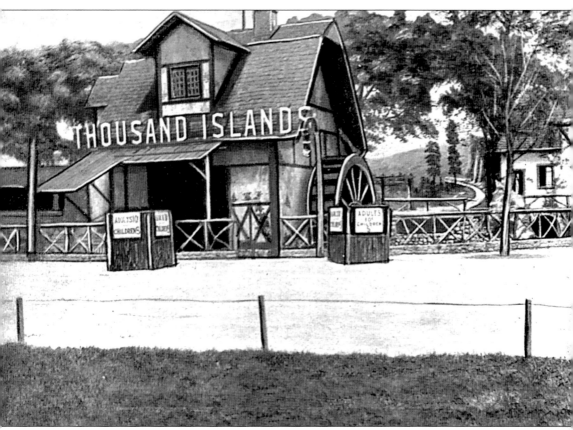

The Thousand Islands was the third ride in the park when it opened. It was composed of 1,000 feet of canals with a chute 28 feet high. The boats passed through the canals at a slow speed, then were brought to the top of the incline where they rapidly descended into a pool of water. The boats returned to the starting point. A large outdoor water wheel operated by a motor, concealed behind scenery, kept the water flowing steadily in the canals. Dark tunnels and scenes to startle the riders were added. The ride was nicknamed Old Mill, Mill on the Floss, Tunnel of Love, and The Mill. For 10 cents, riders could steal a kiss. (Courtesy of Schmidt Collection.)

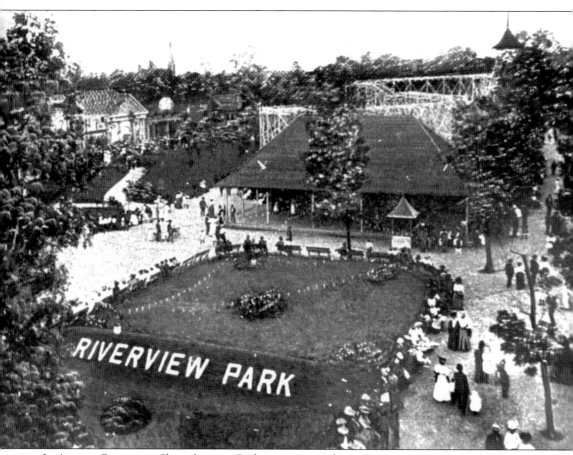

Let's go to Riverview Sharpshooters Park on opening day, July 3, 1904! Patrons were greeted with large areas of green grass, trees, flowers, and benches. Straight ahead is the carousel with the Figure 8 behind it. To the left are the Helter Skelter and House of Mirth funhouses. Concessions in tents were to the right with the miniature railway skirting the area. The groves, with the bandshell, were located in the back 16 acres. (Courtesy of Schmidt Collection.)

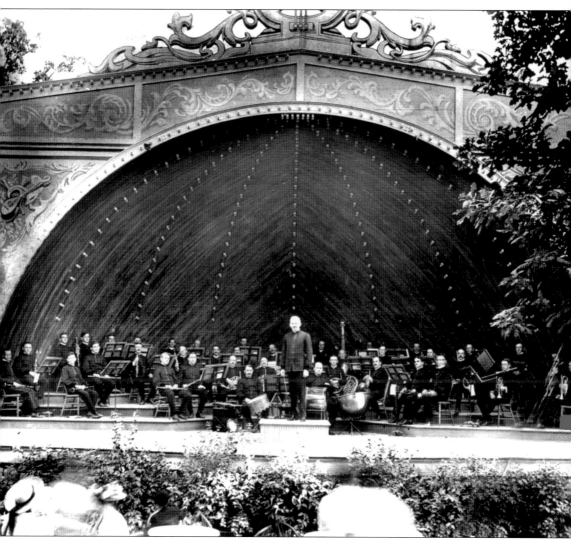

On opening day in the shaded groves, Kopellmeister Herr Louis Kindermann directed the German Imperial Marine Band. He was scheduled to go on to the St. Louis World's Fair and had also played at the Columbian Exposition. The music included popular tunes and favorite classics, "played with spirit and the technical excellence, which gained them a world wide reputation." The band received $3,500 a week for July performances even though Kindermann conducted only two or three days. Other bands that played in 1904 were the 2nd and 7th Regimental Bands, Philippine Constabulary Band, Chicago Military Band, and Bredfield's Military Band. (Courtesy of Schmidt Collection.)

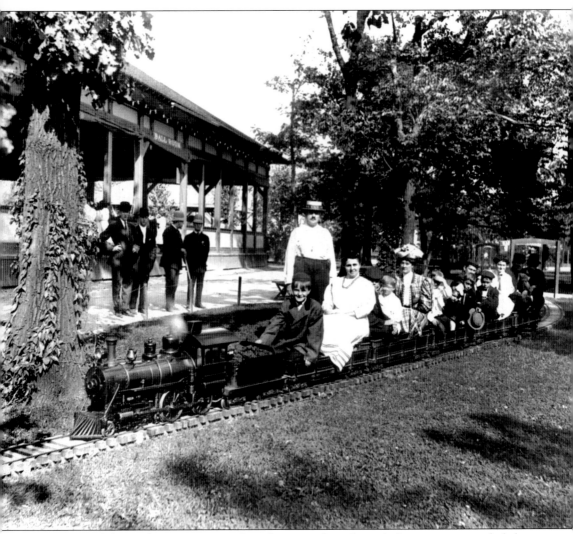

Music and three rides were not enough to draw crowds to the park. Improvements included more rides such as the miniature railroad, and a Ferris wheel called the Pleasure Wheel. There were 6 food concessions, 10 shows, 7 game booths, and 6 exhibits. Specialty acts included a 60-foot highwire dive by Liljen, on fire, twice a day. Balloon ascensions featured Professor Morrison of Canada and Miss De Von Da competing for the Champion of America title and a "purse." Mr. Morall was buried six feet deep for two days, with lights, in a glass enclosed coffin. The railroad was and continued to be a favorite of children throughout the years. (Courtesy of Schmidt Collection.)

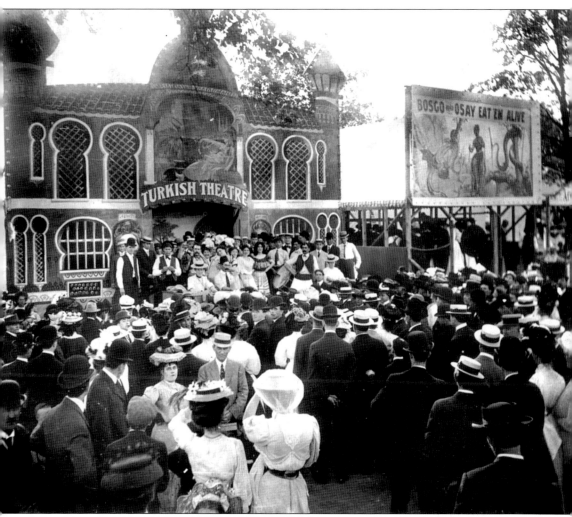

One of the unsung attributes of Riverview was its ability to introduce people to other cultures through shows and exhibits. When Riverview Sharpshooters Park opened, 25 Winnebago Indians camped on the grounds year-round for two years. They took patrons for rides in birch bark canoes and made souvenirs showing their creative abilities. Under Chief Roddy, dances in full native attire were held. This was the first time many citizens met an American Indian. Another attraction emphasized the Turkish people, their dances, costumes, music, and architecture. Note the neighboring display by African Americans. (Courtesy of Schmidt Collection.)

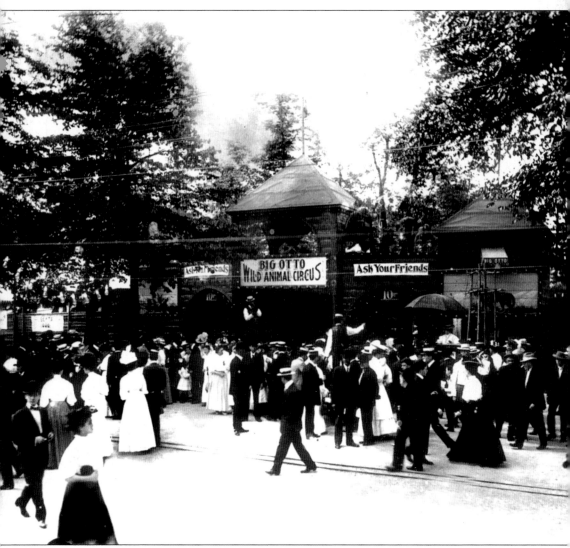

The Big Otto Wild Animal Circus was a great extravaganza. The animals brought in were literally unknown to most of those attending the park in 1904. Imagine seeing an elephant for the first time and being able to ride it! Most of the animals were imported through suppliers in Germany. Otto's contract reads: ". . . [the Circus] shall consist substantially of four large animal acts, six cages of wild animals, at least one cage of birds, and a Riding Animal Concession consisting of riding elephants and camels." Otto reported that he was "training five Siberian Wolves and also Leopards, Pumas, Lions, and placing a dressed lady (and 'good looking') in the center of the arena, then building all around her with animals." (Courtesy of Schmidt Collection.)

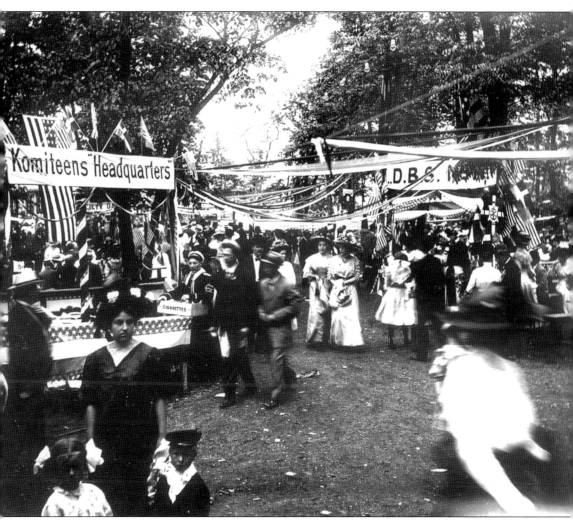

The politicians were quick to go to Riverview Sharpshooters Park. Here they were able to meet the voters—many of whom were new citizens—one to one. The notables included Mayor Carter Harrison, William Jennings Bryon, and others who were scheduled to speak at the "First Gun Campaign" for the Democrats on July 12. On August 13, the Republicans had 30,000 tickets printed for their rally. Fred Busse, John Harlan, and Graeme Stewart competed for the title of "Most Popular Man." (Courtesy of Schmidt Collection.)

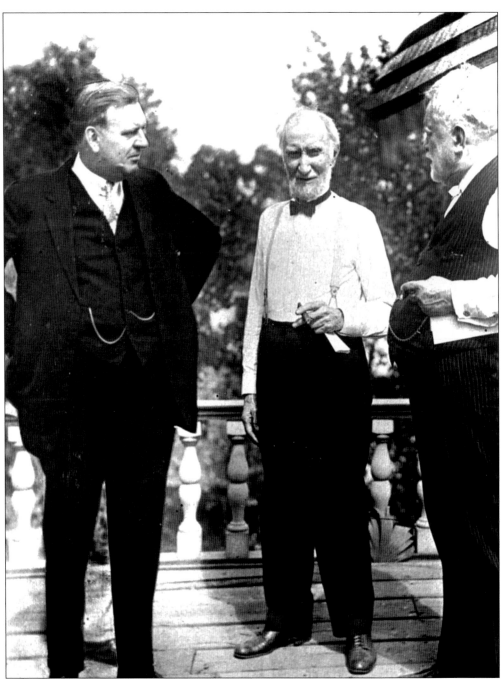

George Schmidt (left) welcomed Senator Joseph Cannon (center), known as "Pink Whiskers," at a political rally. Bill Schmidt stated in a newspaper interview that he remembered "Uncle Joe," who echoed the political ideas of President Theodore Roosevelt. George Schmidt was active in politics and attended the Republican convention that nominated Herbert Hoover. He was a personal friend of Chicago Mayor William Thompson. Over the years scores of candidates and officials came to Riverview to win the votes of a captive audience. (Courtesy of Schmidt Collection.)

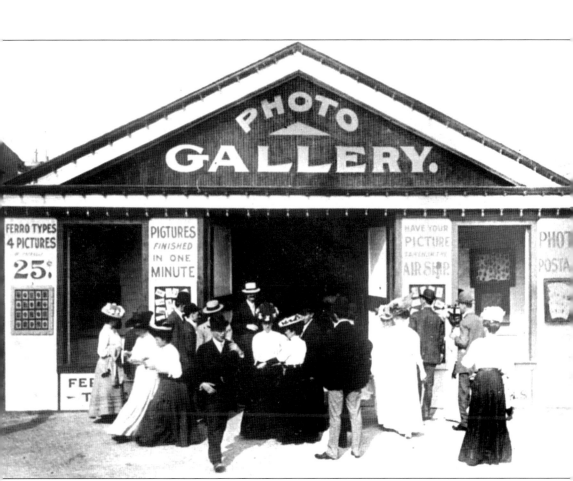

Another innovative invention was introduced at Riverview Sharpshooters Park—photography. William J. Coultry opened his first gallery there in 1902. Pictures were 25 cents for four poses and were finished in one minute. Photos were sent all over the world. The business flourished and four more galleries were added eventually. (Courtesy of Coultry Collection.)

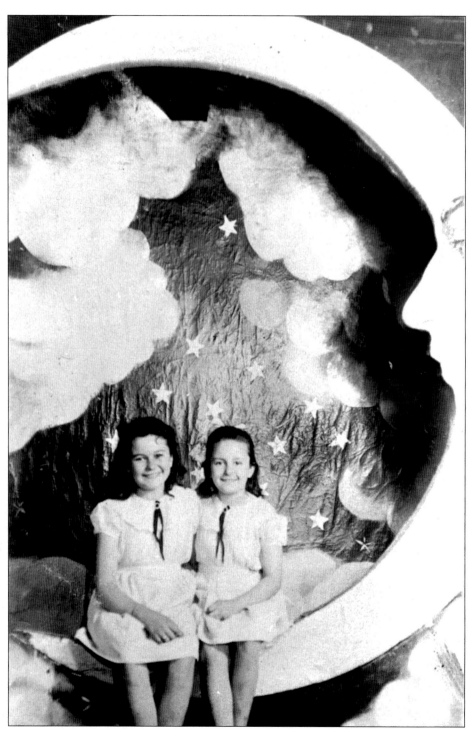

The most popular of photo gallery props was the yellow crescent moon. One couple returned every year with their family to pose on the moon and mark the day they met at Riverview. Other props were new motor cars, the rear platform of an Overland train, surrey with pony, and later a western saloon bar. (Courtesy of Cleary Collection.)

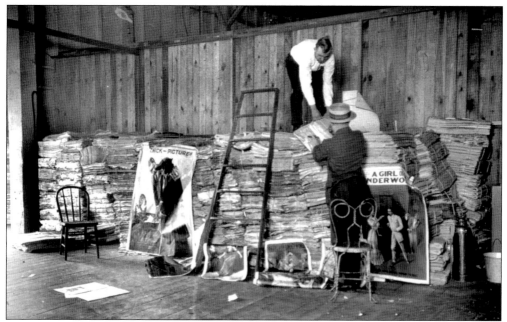

More acres of land were purchased in 1905. The park remained the same but additional buildings were built to house the attractions and for equipment storage. This shows a storage room piled high with posters. (Courtesy of Riverview Archives.)

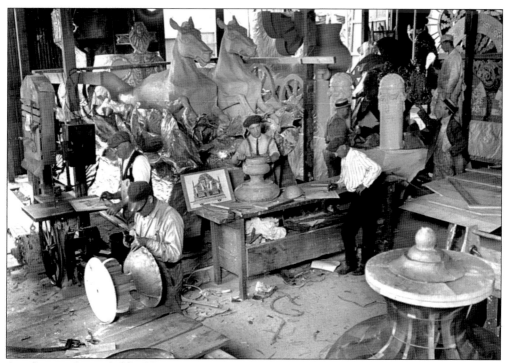

Another sorely needed building was constructed to create a place for painting and repair. Every year the park equipment was inspected, repaired, and repainted. Space was needed to do the job, as shown here. (Courtesy of Riverview Archives.)

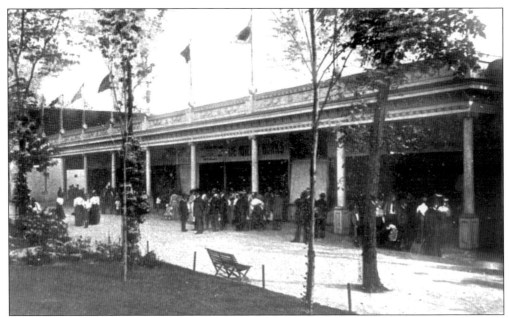

Along the "Pike" (a term coined at the 1893 Columbian Exposition), attractions appeared in flag-bedecked buildings with white pillars dividing the shows. A postcard dated 1905 shows the crowds anxiously waiting while viewing posters at the outside entrance. (Courtesy of Riverview Archives.)

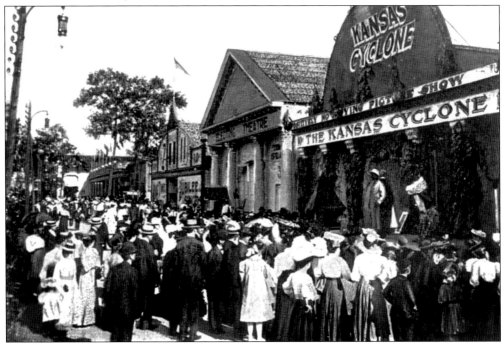

Moving pictures were another new invention for entertainment. The "Kansas Cyclone" was an early catastrophic thriller shown at Riverview Sharpshooters Park. Postcards were popular souvenirs. Early cards were printed in Berlin, Germany. Two million cards were sold annually. (Courtesy of Riverview Archives.)

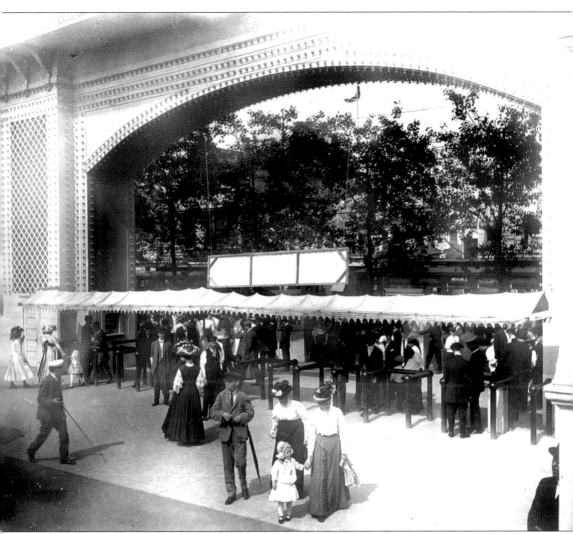

In 1906, the park opened with new rides and attractions. The amusement portion was expanded from 6 to 25 acres, the groves decreased to 15 acres. It was proclaimed "the largest amusement park in the West" and the only "natural park in Chicago." New gates were built, shining in red, white, and blue paint and topped with American flags. The park reopened hoping to break the 1904–1905 attendance record of 100,000. (Courtesy of Schmidt Collection.)

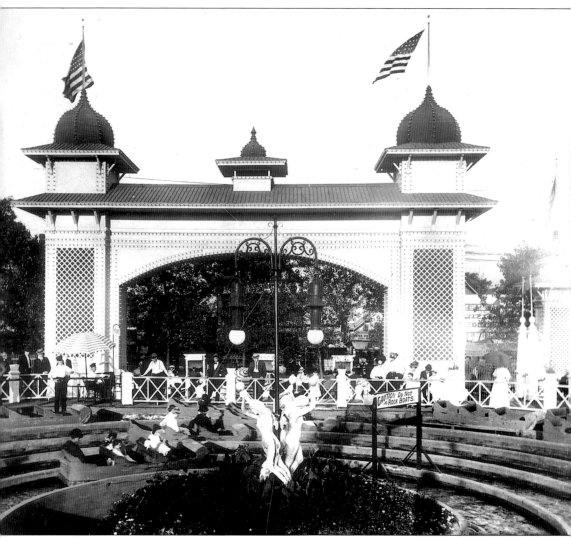

Statues and fountains accented the canals of the Thousand Islands ride just inside the new entrance in 1906. On opening day, the boats were loaded with city dignitaries dressed in top hats, cut-away coats, and striped trousers, guided by George Schmidt. Schmidt's boat tipped accidentally. Slowly it filled with water. No one moved. When the water was neck deep, George said, "Gentlemen I believe we should wade ashore." The newspapers loved the story. (Courtesy of Schmidt Collection.)

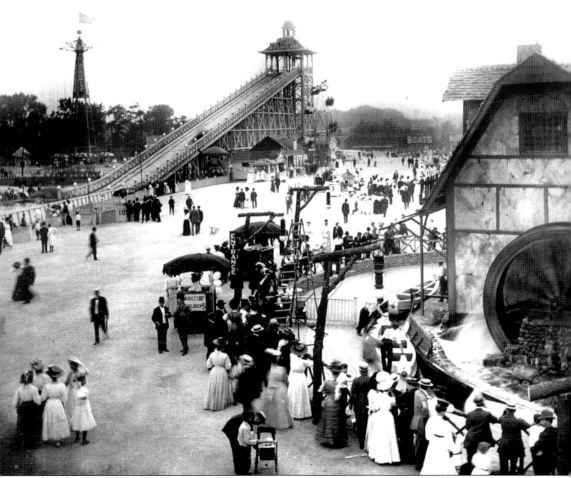

The Chute the Chutes was the main water attraction at Riverview. It stayed in operation for years, proving the efficiency of the craftsmen who built it. Originally built by the Philadelphia Toboggan Company, it was called Shoot the Rapids, combining a coaster and a chute. The boats had wheels, and after going through a dark tunnel of dips and curves, it was raised to the top of the slide. The boat then paused, tipped, and slid down at great speed. It hit the water, providing a shower for the riders, especially those in the back seat. The slide turned upward just before the boat hit the water, so it hopped and skipped, providing great fun for spectators as well as the riders. The building on the right is Thousand Islands. Another new ride, pictured on the left, was the Aerostat, which gave riders the next best thrill to flying. (Courtesy of Schmidt Collection.)

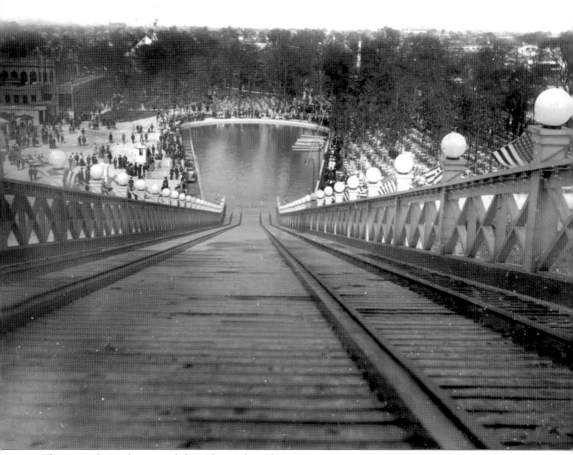

The view from the top of the Chute the Chutes gives an overview of the park. It shows the double track on which boats slide into the water. People loved the ride and never minded getting wet—a guaranteed part of the ride. Most people worried about the boat tipping over when it hit the water, but there was no danger because the lagoon was only 12–15 inches deep. When I rode this ride, I was more worried about the creaking of the timbers as the boat rose to the top of the slide. It was so well built, however, that when it came time to demolish the Chutes in 1967, a demolition ball had to be used to destroy the main structure. (Courtesy of Schmidt Collection.)

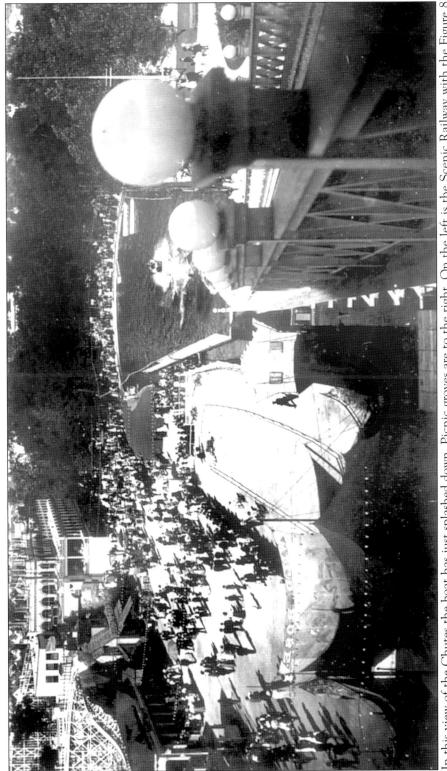

In this view of the Chutes the boat has just splashed down. Picnic groves are to the right. On the left is the Scenic Railway with the Figure 8 beyond. The new Casino building under construction can be seen on the upper left. (Courtesy of Riverview Archives.)

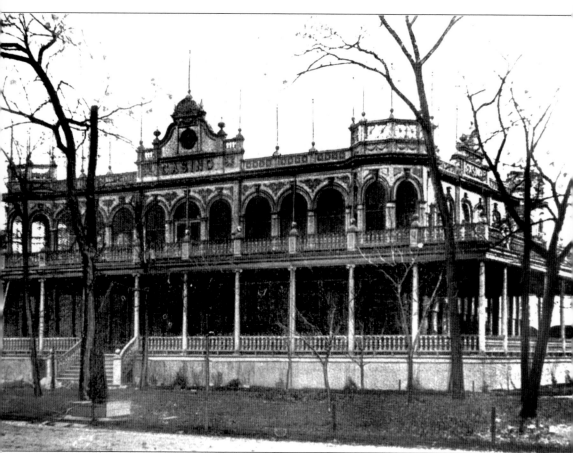

Pillars and Gothic windows accented the Casino building, which housed a very large restaurant specializing in German cuisine. It was suspected that the upper floor was used for gambling but only slot machines were ever discovered in the Penny Arcades. The second floor was eventually removed and the building converted to office space. Note the many lightning rods on the roof. Fire was a disaster at any park. (Courtesy of Riverview Archives.)

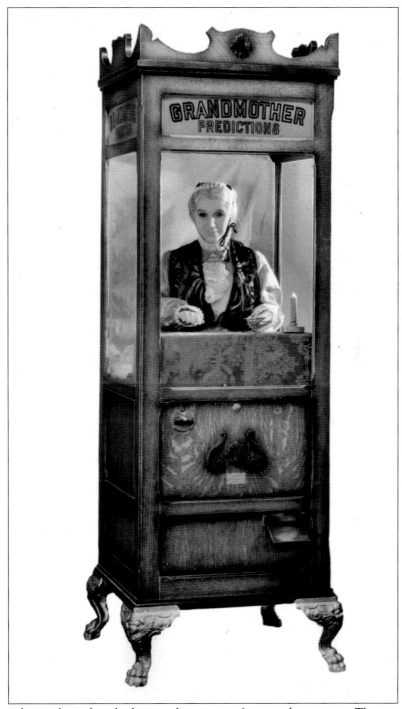

Penny Arcades, acclaimed as the best in the country, fascinated customers. There were games of all kinds, and they were electric! This new attraction also had penny peep shows with very suggestive names that were actually very innocent. The "Nudist Colony" was actually an ant hill, with naked ants! One popular machine, "Gypsy," told fortunes. For 10 cents a person would receive a very positive future in writing. (Courtesy of Riverview Archives.)

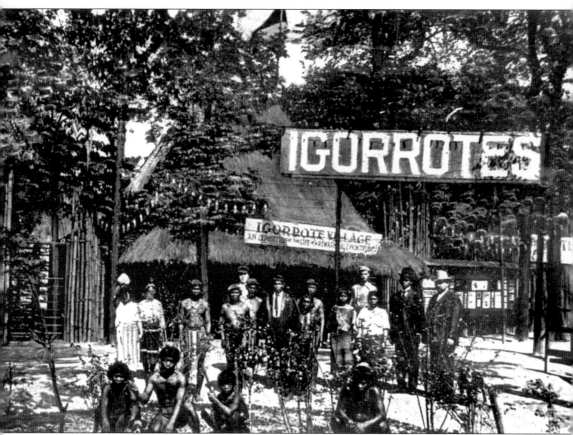

The American Indians were replaced with Igorrotes, natives of the Philippine Islands. Patrons had an opportunity to meet still another ethnic group from a distant part of the world. Natives built huts, danced with drum accompaniment, and shared native stories. One newspaper reported these natives ate dogs but assured the readers these were not supplied by the management. (Courtesy of Riverview Archives.)

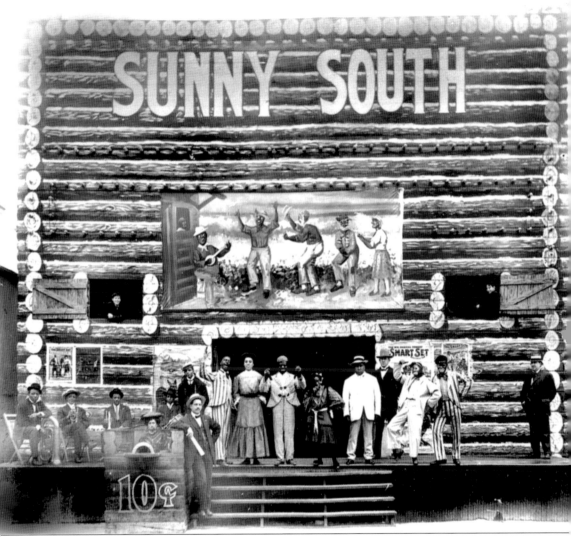

In this show, "Sunny South", viewers witnessed dance, plays, and singing of the exhibit's African-American performers. Inside were replicas of their homes and displays of cotton designed to illustrate how it was picked and baled. (Courtesy of Schmidt Collection.)

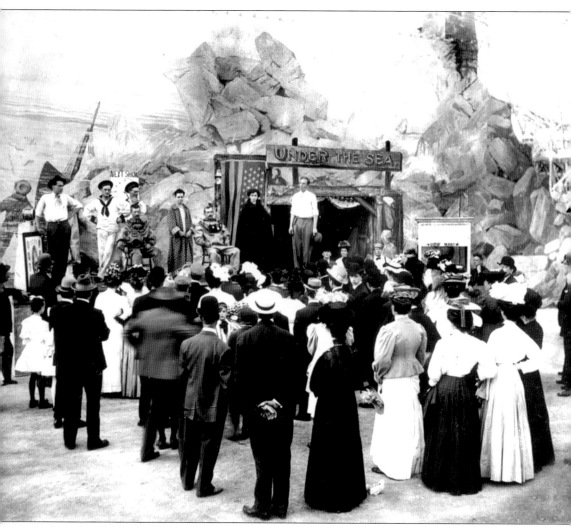

Jules Verne influenced this sideshow attraction, "Under the Sea." An illusion ride transported the audience into a place they undoubtedly would never experience in any other way. The illusion show was staged in a large building, and riders were seated in a submarine-shaped car that held about 30 persons. The illusion was aided by projecting underwater scenes on the inner walls with whales, giant turtles, sharks, and stingrays that got so close that passengers screamed and clung to each other. A lecturer pointed out these underwater wonders. (Courtesy of Schmidt Collection.)

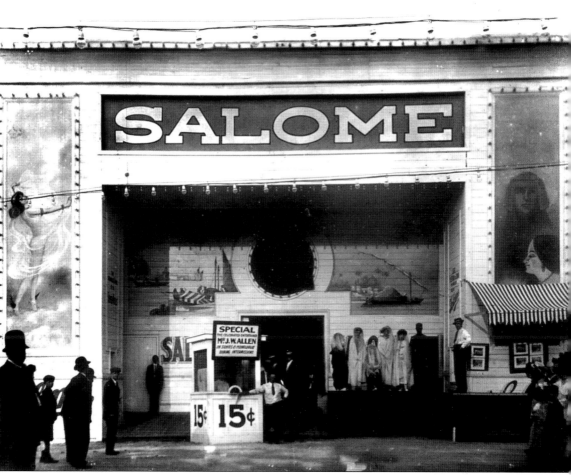

The shocking "Dance of the Seven Veils" performed at the 1893 Columbian Exposition was brought to Riverview, complete with attendants, guards, and slave girls. The performances were wild and seductive. Authentic costumes in the show were revealing and contrasted with the lady customers who wore leg-of-mutton sleeve blouses, long skirts, and feather-bedecked hats. The costumes of the show provided many a back-of-the-hand comment and shocked stare—but many of the men enjoyed every minute of it. The dance originated in Hammerstein's play, *Salome*. (Courtesy of Schmidt Collection.)

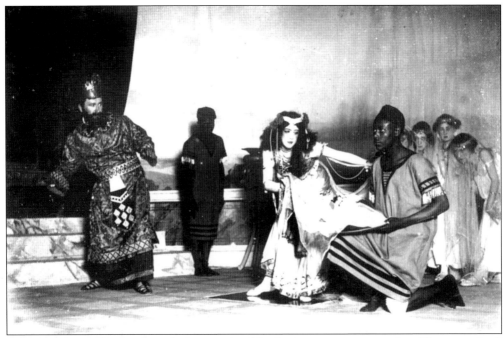

At a time when ladies dared not show even an ankle, this attraction was considered "very naughty." Though the dance itself was a ballet, its fiery twirling seemed to titillate audiences—especially the men. (Courtesy of Schmidt Collection.)

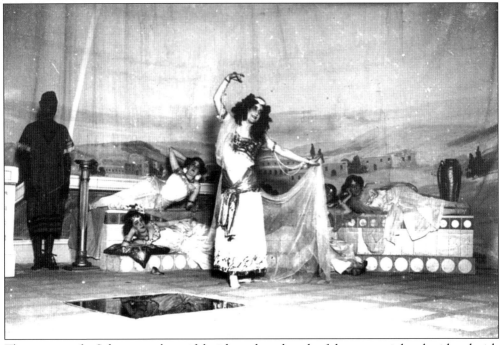

The costumes for *Salome* were beautiful with yards and yards of sheer material embroidered with pearls and beads. The girdle and brassiere were of gold lamè. Jewels hung from the neckline and head dress. (Courtesy of Schmidt Collection.)

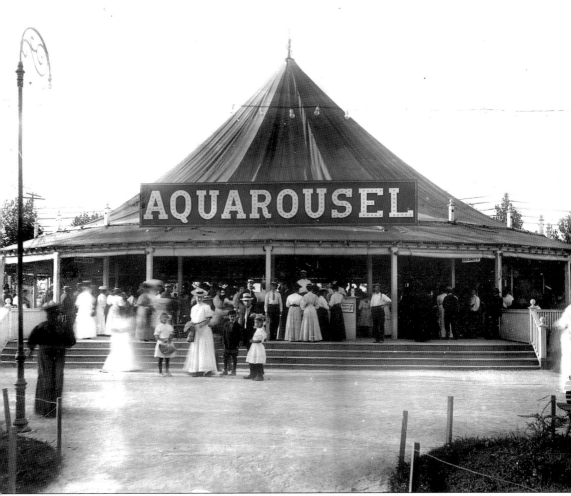

It was a surprise to find an aquatic carousel at Riverview. This ride was originally a round pontoon 100 feet in diameter, which floated on the surface of the water. It was fastened by a center post to the bottom of the lake or pond. Riverview's Aquarousel used pretty, swan-shaped floats propelled by motors that kept them moving around the perimeter. It seated 200 passengers. Other parks used sails and depended on the wind to turn the ride. (Courtesy of Schmidt Collection.)

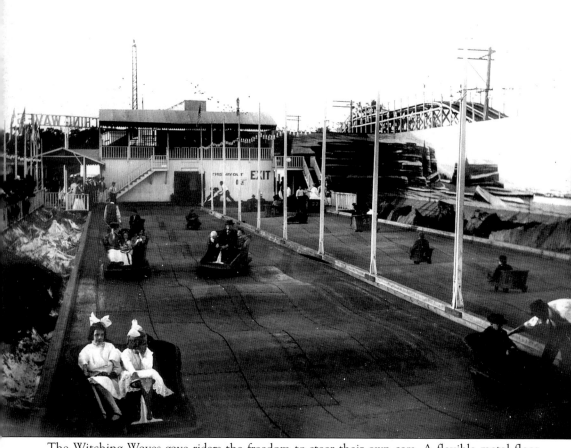

The Witching Waves gave riders the freedom to steer their own cars. A flexible metal floor, controlled by levers beneath the floor, created a continuous undulating motion. No part of the floor moved forward. The action of the so-called "waves" and the steering skills of the riders generated forward momentum. Automobiles were becoming more and more popular and rides allowing patrons to "drive" were exciting. Another ride that offered this opportunity was the Dodgem. (Courtesy of Schmidt Collection.)

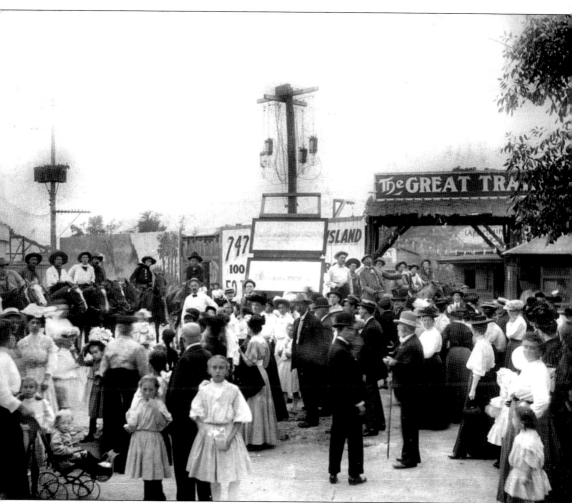

The shows along the Pike included a Wild West show that gave Tom Mix his start in show business. The Great Train Robbery was described as follows: "The show begins with the train being halted and the bandits, wearing pistols, robbing the passengers. Soon a gunfight breaks out—patrons scream—and there is the sound of the posse approaching on horseback (these hoof beats came from behind the plaster mountain). The bandits leap on their horses and are out of sight when the curtain closes." In this picture, Tom Mix is to the left of the 747 sign. He's wearing his famous black hat. (Courtesy of Schmidt Collection.)

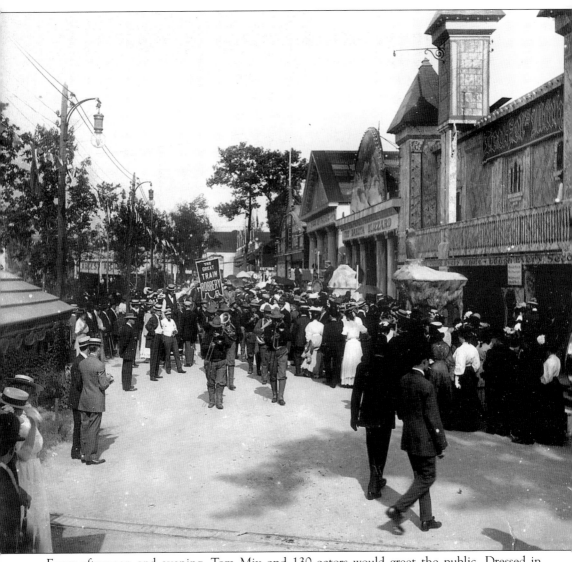

Every afternoon and evening, Tom Mix and 130 actors would greet the public. Dressed in western costumes, they created quite a scene. Parades led by 60 actors on horseback moved along the Pike announcing the performances. Tom Mix was "in the movies" at the Essany Studios at Byron and Western Avenues. His salary was $1.50 an hour at Riverview. For this he jumped from a high mountain onto a horse, performed in a play, and paraded twice a day. He earned his money. (Courtesy of Schmidt Collection.)

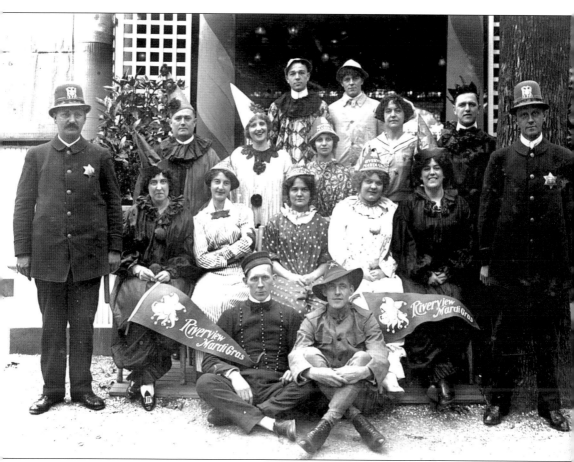

Mardi Gras was even enjoyed by employees. The magical event developed into a customer "fling." Anyone in costume was admitted free of charge and could march in the parade with the floats and bands. The streets were filled with nine tons of confetti for four weeks. Maintenance crews had a little rest from cleaning up and the police were kept busy with crowd control. (Courtesy of Schmidt Collection.)

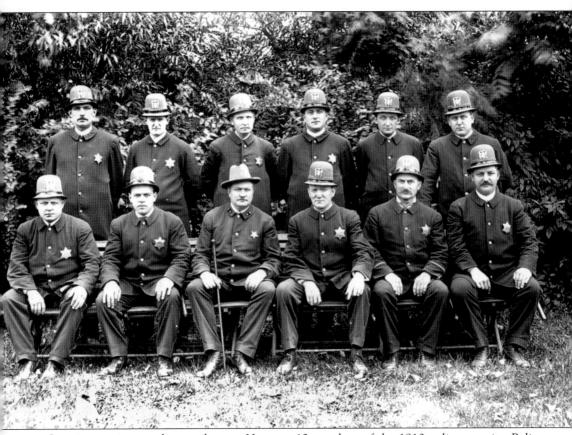

Security was increased as need arose. Here are 12 members of the 1910 police security. Police were hired by the park, but Chicago's Roby Street Station was close by and also helped with traffic and crowd control. Later, a security system was installed and help arrived in only minutes if a problem occurred. Riverview eventually had its own fire and police departments. (Courtesy of Schmidt Collection.)

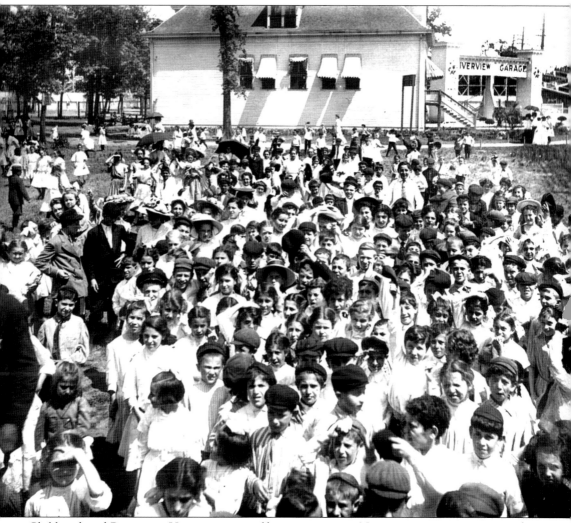

Children loved Riverview. Here is a group of happy customers. Newspaper carriers were treated to a day at Riverview every year and school kids got a day off to play at the park, thanks to Mayor Thompson. Notice the "Garage" sign in the background. (Courtesy of Schmidt Collection.)

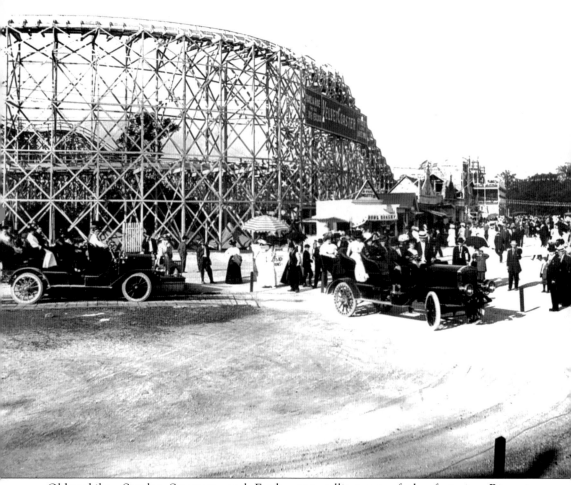

Oldsmobiles, Stanley Steamers, and Fords were rolling out of the factories. Riverview management recognized the need for parking and built its first parking area in 1907 for 1,000 cars. Eventually it provided five parking areas, accommodating 5,000 autos. The new Velvet Coaster is in the background. (Courtesy of Schmidt Collection.)

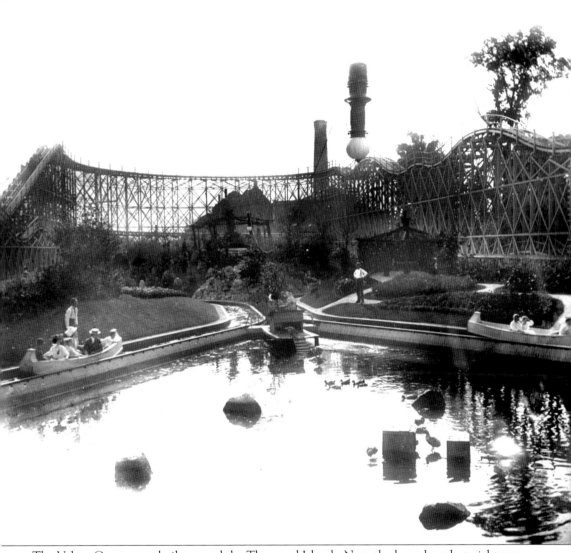

The Velvet Coaster was built around the Thousand Islands. Note the long, broad, straight areas of the ride. Small dips are on the right. This coaster developed new mechanisms later copied by coaster inventors. (Courtesy of Schmidt Collection.)

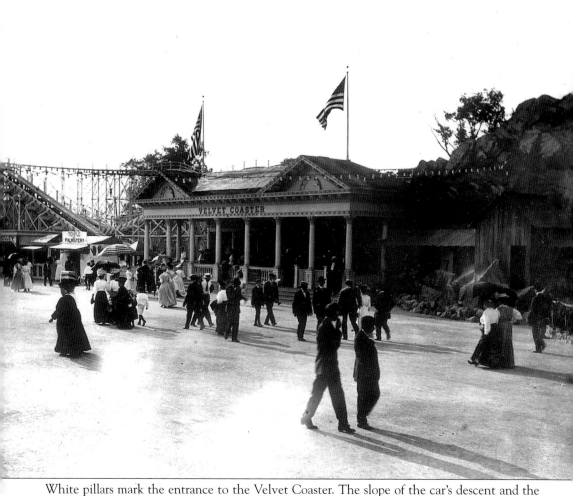

White pillars mark the entrance to the Velvet Coaster. The slope of the car's descent and the long expanse between the curves on the left shows the ride was far from wild. But it was an important roller coaster development. (Courtesy of Schmidt Collection.)

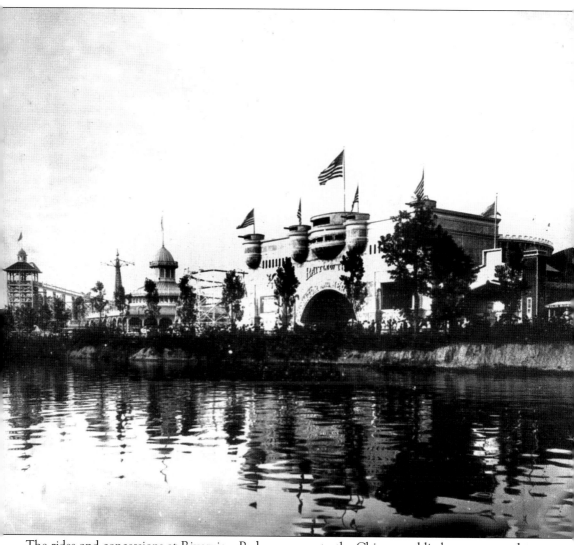

The rides and concessions at Riverview Park were new to the Chicago public but were tested at other parks, fairs, and expositions. Information was gathered on each ride in relation to attendance, cost of operation, and maintenance before a contract was signed committing a percentage of the profit to the park management. The Cyclorama appeared in 1898 at the Trans-Mississippi Exposition in Omaha. It was a major attraction on the Midway. These shows made history come alive. The Civil War battle of the *Monitor* and the *Merrimac* captured audiences with light, sound, and illusion. (Courtesy of Schmidt Collection.)

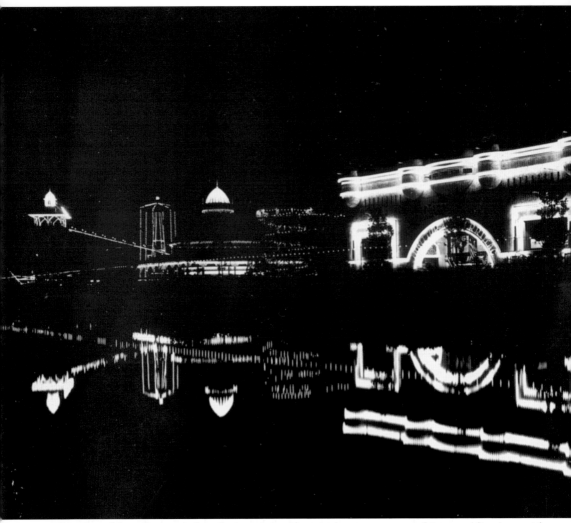

This show, like others, was based on a major historical event presented in an auditorium with a stage. Action scenes were created in miniature and natural items were arranged in front of them. In the dark, the audience lost all concept of depth. Every thing looked real. At night the large building was spectacular. Thousands of lights outlined it and the other rides. Pictured at left are the Chutes, Aerostat, the new Merry-Go-Round building, and the Figure 8. (Courtesy of Schmidt Collection.)

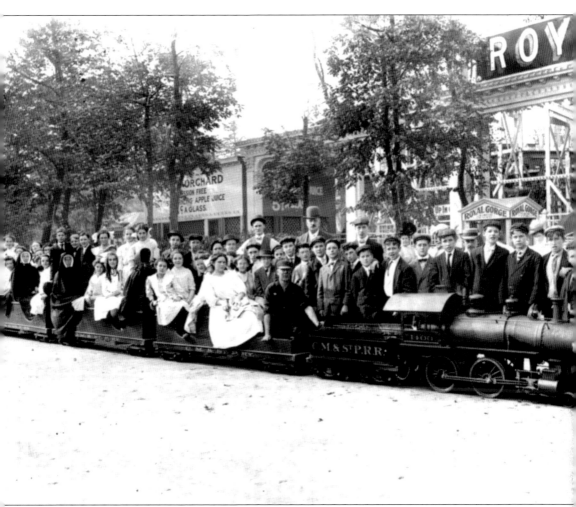

Miniature trains were part of Riverview during its entire operation. In 1904, the miniature locomotives, modeled after the famous 999, were made by the Cagney Company, which had been making miniature trains since 1892. Pictured is a group from a Catholic Church and/or school. Note the nuns to the left of the picture seated on the train. The trains burned coal or coke and ran on 14 to 24 gauge tracks. By 1908 trains traversed Riverview. One ran near the main walk and the other chugged by the river. The sound of the engine, the clang of the bell, and the smell of the smoke coming out of the smokestack made every child on the train feel grown up. (Courtesy of Schmidt Collection.)

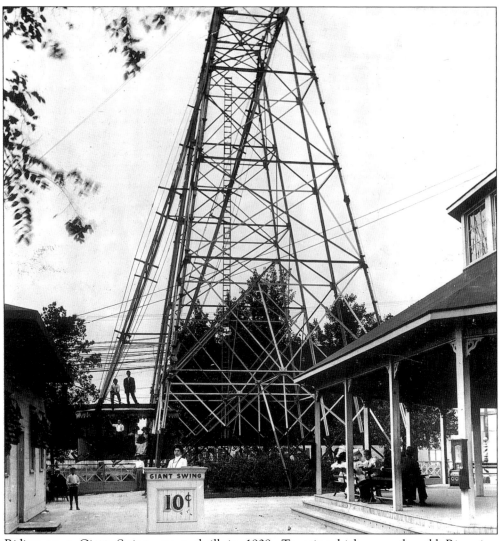

Riding on a Giant Swing was a thrill in 1908. Towering high near the old Riverview Merry-Go-Round building, it gave the riders the best "swing" anyone could have for 10 cents. Seated in a gondola-shaped car, the swing began slowly, gaining speed every minute, making the riders scream with pleasure but not fear. It was not like the Aerostat, which flung the cars out into space; this was a boat swing—it swung back and forth. (Courtesy of Schmidt Collection.)

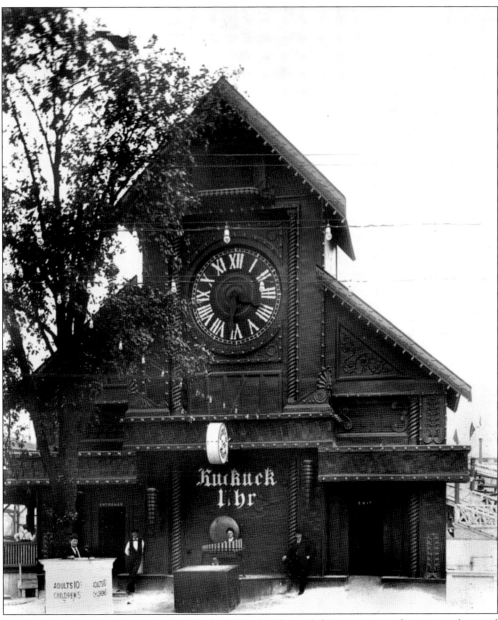

Among the new attractions was the Cuckoo Clock. This exhibit was extraordinary as it featured animated mechanical figures that performed every hour. This mechanical achievement from Germany was very popular and was adopted by street musicians who used a mechanical monkey on their hand operated organs. The most famous clock of this kind is located in Strasbourg, Germany. (Courtesy of Schmidt Collection.)

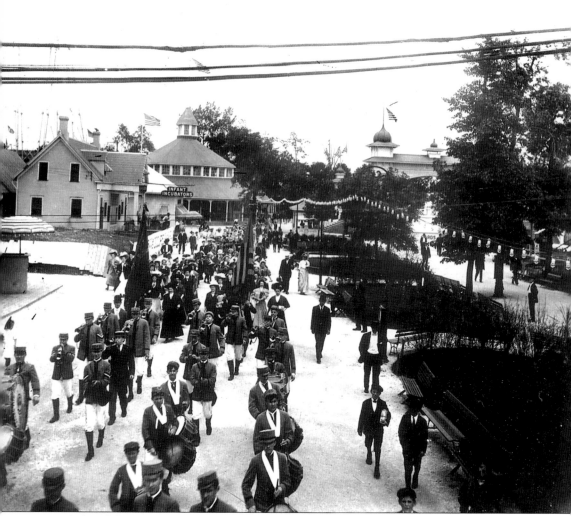

People loved the parades. Parades occurred every day at Riverview and were performed by civic, social, and industrial groups. The building on the left is the Infant Incubator building. Live premature babies were brought to amusement parks because the medical profession had not accepted the machine for hospitals. A German doctor, Martin Counery, brought the machines to parks as here large groups of people would learn their life saving qualities. Cows were housed in the barn directly behind this building, supplying milk for the babies. A core of nurses were on duty around the clock with a doctor "on call" at all times. It is not known how many babies were saved at Riverview. (Courtesy of Schmidt Collection.)

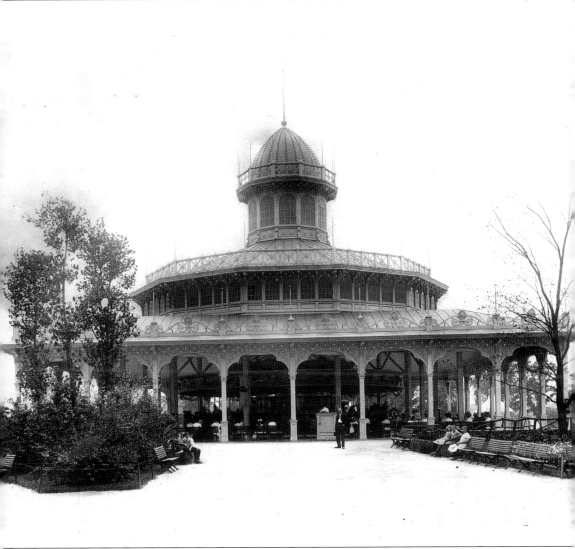

In anticipation of the arrival of the special carousel a new building was erected. The new domed building was designed by H.P. Schmeck. This building housed the carousel and was remodeled in 1966, one year before the park closed. (Courtesy of Schmidt Collection.)

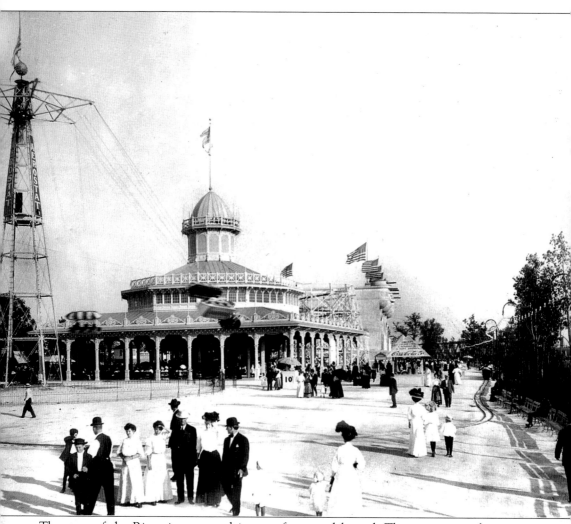

The story of the Riverview carousel is one of repeated legend. The story states that young George Schmidt was at a fair in Germany and got lost. Someone placed him on top of the carousel so he could try and locate his parents. The music calmed him and he fell in love with the ride. In 1906, a Merry-Go-Round was ordered from the Philadelphia Toboggan Company. (Courtesy of Schmidt Collection.)

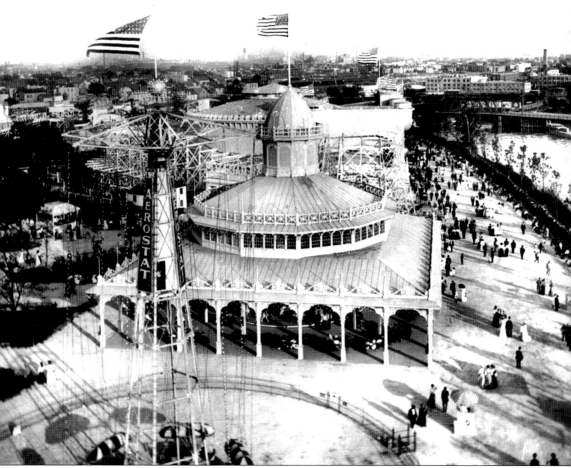

This is an aerial photo of the ornate carousel building built in 1908 for the famous Riverview ride. It was right on the edge of the Chicago River, whose flow had been reversed earlier, and stands as one of the engineering feats of the century. The steamboat *Welcome* carried passengers from the Clark Street Bridge to Riverview. The Aerostat is in the foreground on the left; this ride consisted of a high steel tower, which had six extended radial arms. A carriage was suspended from each arm on a long steel cable. Operated by a motor, the ride rotated at high speed and the seats swung out in a wide circle. (Courtesy of Schmidt Collection.)

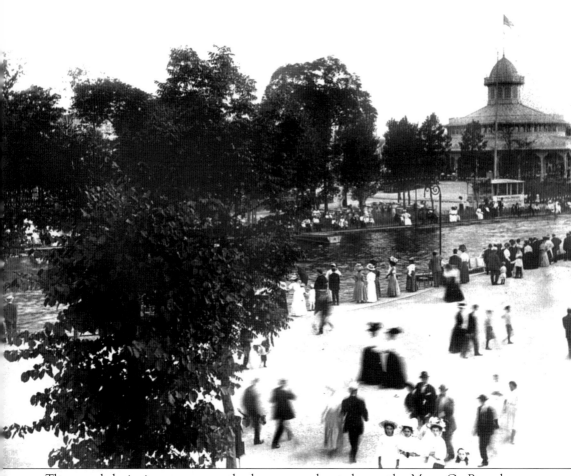

The crowded picnic grove across the lagoon was located near the Merry-Go-Round; many people ate meals there where they could watch as their children rode the horses. There is a small food booth on the right where a new delicacy called the "hot dog" was available. The sausages were served on a bun, not on a paper napkin as before. Only Oscar Mayer sausages were served at Riverview as he was a personal friend of George Schmidt. The foot-long hot dog was invented at Riverview. (Courtesy of Schmidt Collection.)

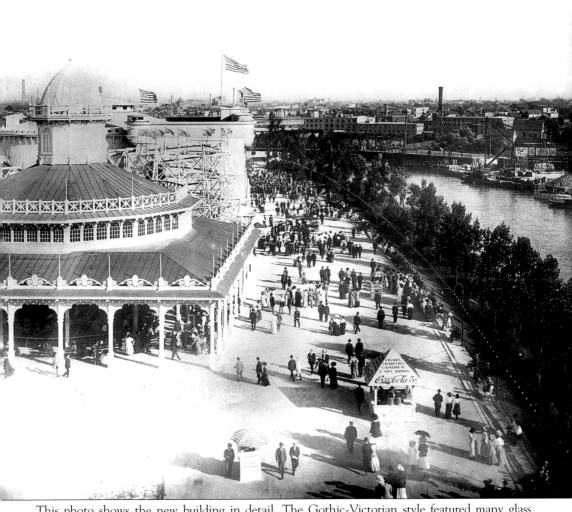

This photo shows the new building in detail. The Gothic-Victorian style featured many glass windows. Lightning rods were decorative as well. Note the Coca-Cola stand nearby. The ride attracted customers by the scores. Vendors had good sales at this location. Other treats included cotton candy and taffy pulled on shiny machines. The miniature railroad is next to the river and the Figure 8 is directly behind the new building. (Courtesy of Schmidt Collection.)

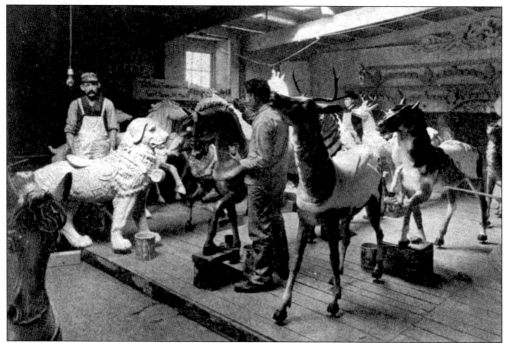

The Riverview Merry-Go-Round was always a highlight of the park. It was commissioned in 1906. The Philadelphia Toboggan Company had just hired German, Italian, and Austrian carvers. Their skills were unsurpassed and finished figures classify today as outstanding pieces of American folk art. The workshop seen here produced only 17 carousels, some with a variety of animals. (Courtesy of Philadelphia Toboggan Co. Collection.)

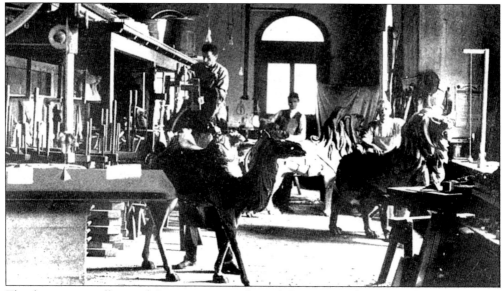

The figures were all carved from one piece of wood. Later animals were made of aluminum, plaster, or resin using molds for various interchangeable parts. These were fastened together to make a complete animal. They resulted in repetitive look-alikes. (Courtesy of Philadelphia Toboggan Co. Collection.)

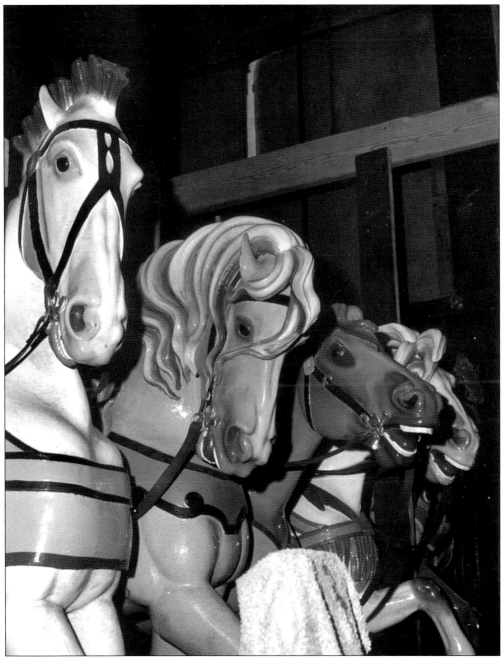

Every horse on the Riverview ride was an individual—no two personalities were alike. The decorations depicted the kind of pony each represented. The legs and heads were placed in action positions creating a natural appearance. The music on the ride was supplied by an organ, which used paper music rolls. (Photo by Dolores Haugh.)

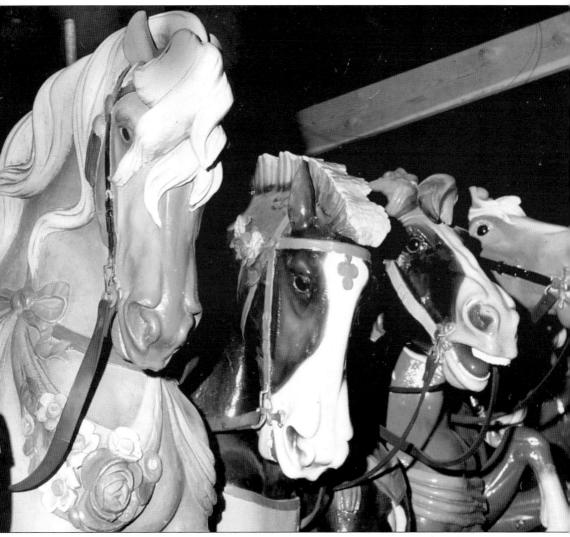

The horse on the left is decorated with hand carved roses as were medieval mounts. The restlessness of the other horses is felt in their poses. From 1908 to 1917, 1,186,560 customers rode the Merry-Go-Round. The music was special, with tinkling notes and a crash of cymbals. However, in the 1960s the music rolls were replaced with records by Ken Griffin. The music was never the same. (Photo by Dolores Haugh.)

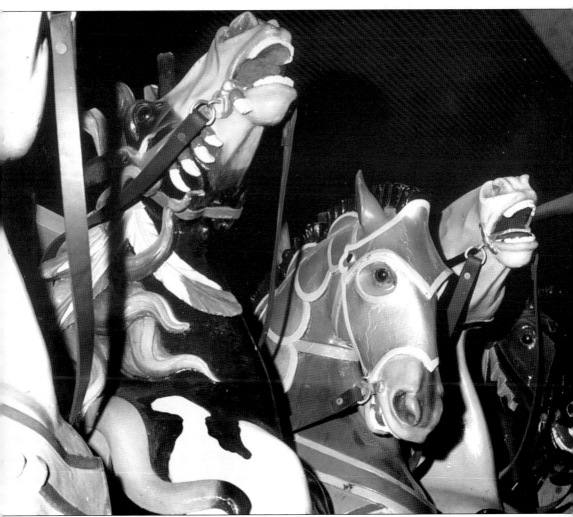

The Indian horse, with feathers flying from its bridle, is beside the armored knight's mount. Action is evident in every line of the designs. There were 25 carvers at the Philadelphia Toboggan Company. It is believed that John Zalar carved the Riverview horses. He became ill and had to move to a warmer climate but continued carving. Can you hear the third pony neigh? (Photo by Dolores Haugh.)

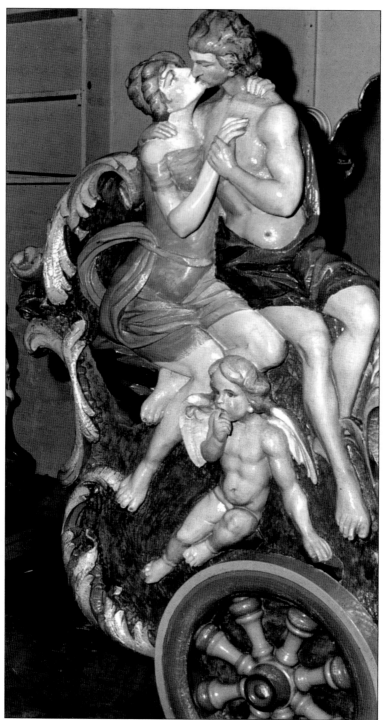

There were four Lover Chariots on the new ride. Two were on the outside perimeter, seating three people. The other two were on the inside perimeter and seated two. The cupids are repeated on the upper outside rim. Note the details on the figures, defined down to their toes. (Photo by Dolores Haugh.)

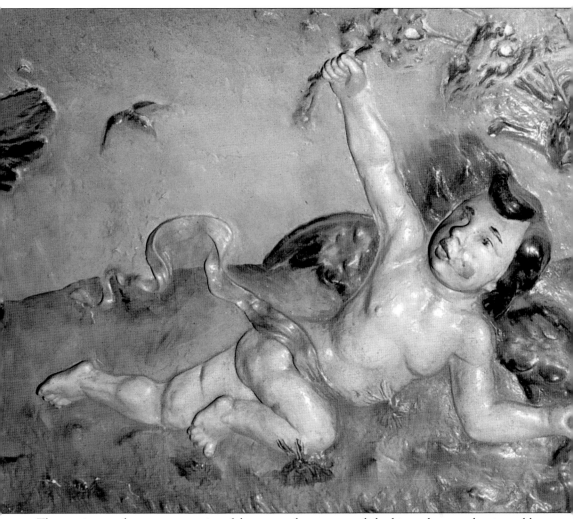

The carving on the outer upper rim of the carousel was accomplished in such a way that it could not be duplicated when being restored. The colors used on the entire original ride were pastels accented with gold leaf. Scenery enclosed the machinery with mirrors above. The carousel cost $100,000, but paid for itself many time over. (Photo by Dolores Haugh.)

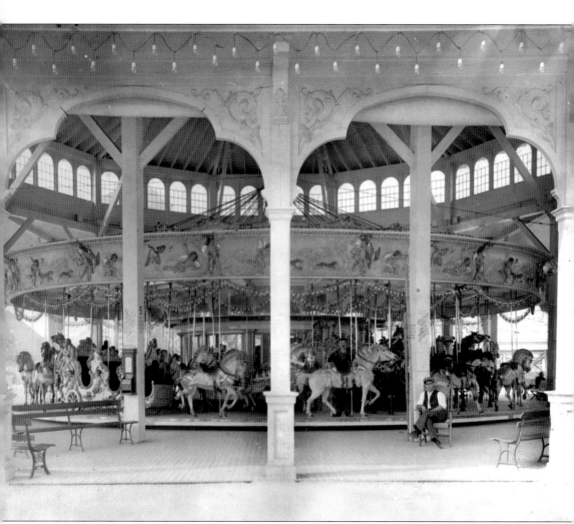

The long journey for the 70 horses began in 1908. The 50-foot wheel had five rows of horses across. It was one of only three such rides made by the Philadelphia Toboggan Company. It is the only one still in operation, now at Six Flags in Atlanta, Georgia. A sign "Riverview Carousel" marks its place today. (Courtesy of Schmidt Collection.)

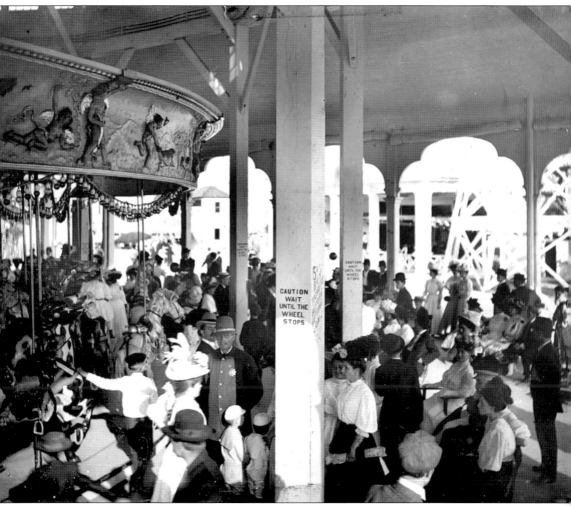

There were 4 rows of jumpers, 14 stationery horses on the outside perimeter, and 56 in the center. Customers waited in line to ride a favorite horse. Police controlled the crowds. Notables from presidents to politicians, actors to judges rode for fun. Some patrons returned every year, others returned with their children and grandchildren—and it only cost a dime to ride. In the 1920s, another small Merry-Go-Round was added called the "Winner." The big carousel was called the "Fairyland." At full speed the Fairyland went 14 miles per hour. (Courtesy of Schmidt Collection.)

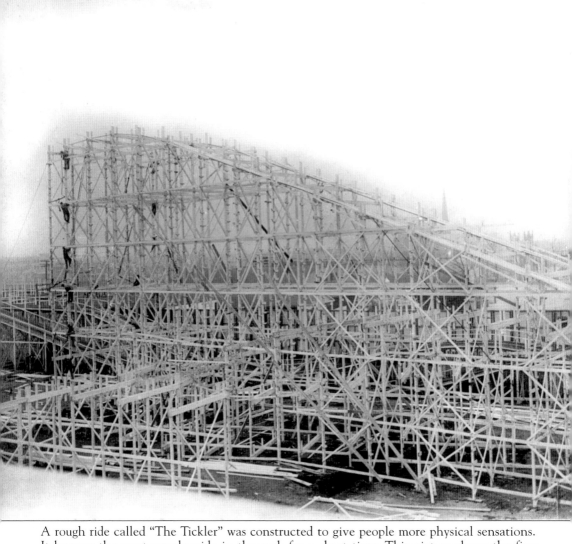

A rough ride called "The Tickler" was constructed to give people more physical sensations. It became the most popular ride in the park for a short time. This picture shows the five carpenters building the framework for the ride. All timber was treated to prevent rot. (Courtesy of Schmidt Collection.)

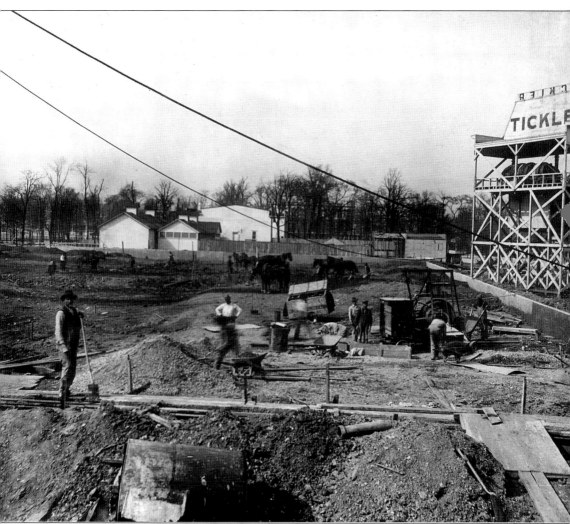

Workmen had to make deep footings on all of the rides as the park was so close to the Chicago River. At one point, the river ran through the park and had to be re-routed and land had to be filled to make it safe. A building even had to be moved when the ground became unsafe at a later date. (Courtesy of Schmidt Collection.)

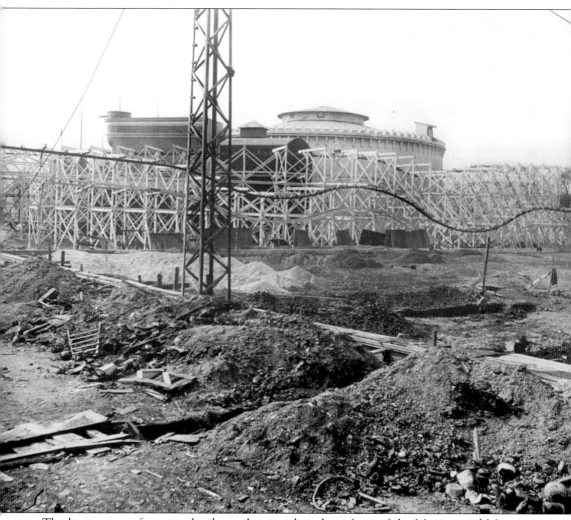

The long course of posts and rails can be seen directly in front of the Monitor and Merrimac building. Invented in 1906, The Tickler was designed to "jostle, jolt and jounce" the riders. In circular cars they were pulled through the tunnel on swivel caster wheels with rubber bumping rings on the outside. Cars were drawn up an incline by a chain conveyor then pulled downward by gravity. They whirled back to the terminal and the passengers were violently thrown together and were so entangled they often needed to be helped from the ride. (Courtesy of Schmidt Collection.)

In 1910, "Chicago's Riverview Exposition" was also called "The Wonderland of the Woods" offering "the lure of the woods." It was one of only a few in the country to combine nature and amusement park attractions. Another new ride was built called the "Scenic Railway." The scenery was built on a framework covered with canvas. Scenes of mountains and trees were hand painted. It was constructed near the Thousand Islands ride. (Courtesy of Schmidt Collection.)

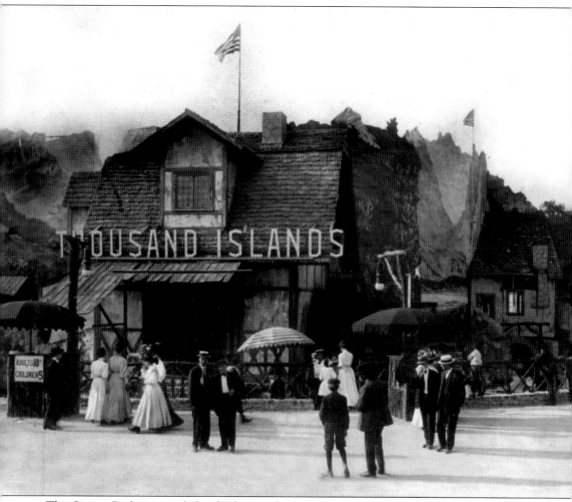

The Scenic Railway, just behind Thousand Islands, was the first roller coaster to adopt the oval track with sharp dips and curves. As the car passed over a moving cable, grips under the car would open and close. The cars were mounted on three small railway trucks. Dark tunnels built over the tracks were flooded with light when tripped and various scenes surprised the riders. Future roller coaster manufacturers copied these new innovations. At Riverview, the Greyhound coaster was built in 1910. A greyhound dog was buried under the ride! (Courtesy of Schmidt Collection.)

The Motorcycle and Auto Route to Riverview

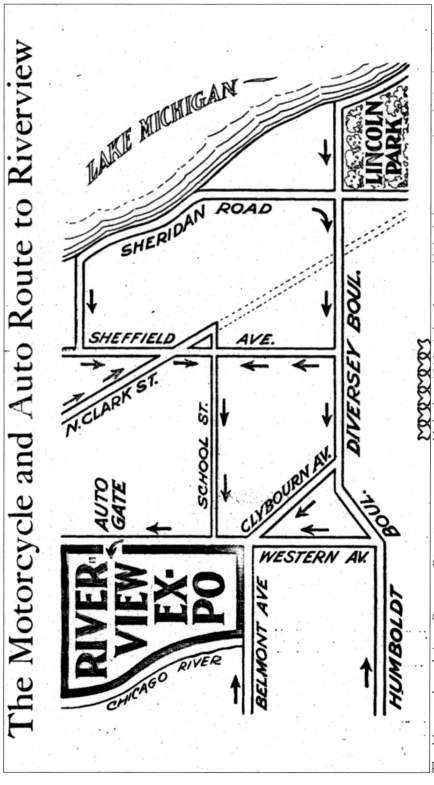

The Motorcycle and Auto Route to Riverview map was published in 1910. A brochure published the same year listed 18 rides, 9 shows, 6 specialty acts, 2 spectaculars (the *Monitor* and the *Merrimac*, and the *Creation*), plus 13 devices: "more than any other ten parks in the world today." It was named "Chicago's Riverview Exhibition." The name did not last more than four years. (Courtesy of Riverview Archives.)

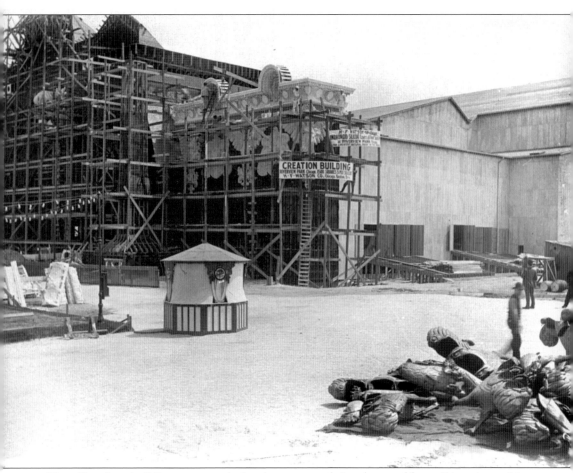

The Creation building presented the largest angel in the world to Riverview visitors. Construction of the special building was supervised by Chief Electrical Engineer Arthur Cleary. Details of the program presentation included the complicated process needed for the lighting and sound. Creation of the world had to be exciting and colorful using all of the new lighting effects and sound. (Courtesy of Cleary Collection.)

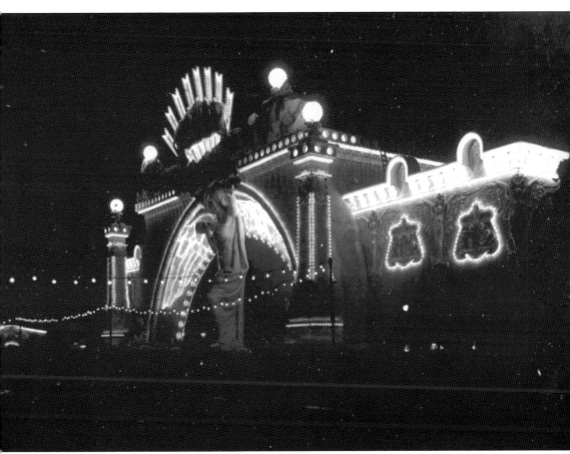

The Creation building was a spectacular scene at night. Outlined in hundreds of electric lights, the wings of the angel, which measured 102 feet from wing tip to wing tip, provided a bright background for the full figure. The show was a spectacular attraction, new to the public. The building was declared "the most ornate of its kind in any park or exhibition." (Courtesy of Cleary Collection.)

When De Recat's Battler Revue, directed by M. Emile De Recat, opened at Riverview in 1917, it was accompanied by an all-star cast of Beauty Corps de Ballet. Among the songs played were "So Long Mother," "Along the Way to Waikiki," "For You a Rose," "Cherry Blossoms," and "Egypt in Your Dreamy Eyes." Songs were copyrighted and published by Jerome H. Remick & Co. (Courtesy of Riverview Archives.)

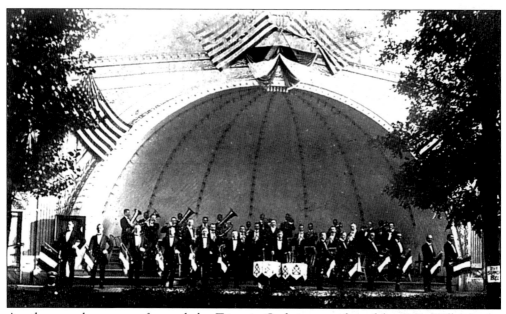

Another popular concert featured the Tsingtau Orchestra conducted by O.K. Wille. It was sponsored by the Astre–Hungarian Relief Association. (Courtesy of Riverview Archives.)

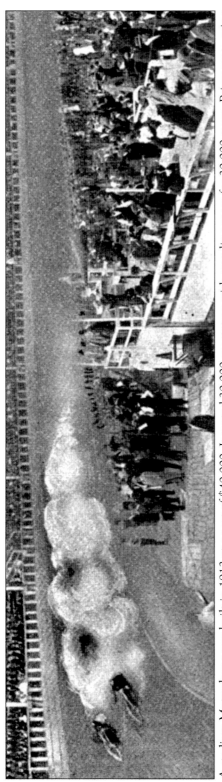

A stadium Motordrone was built in 1912 at a cost of $40,000. It seated 30,000 spectators with standing room for 30,000 more. Prizes amounting to $810,000 were awarded. The Motordrone welcomed professionals, trade riders, and private owners to race. Records set by Barney Oldfield created a question asked when anyone was extra fast, "Who do you think you are, Barney Oldfield?" (Courtesy of Riverview Archives.)

"Whee—it's fun to ride the Whip—it's just the right size," these little ladies seem to say. Kiddyland was a new concept in amusement park entertainment. The most popular rides were created in miniature, to scale, allowing children to ride alone. This family attraction became so popular a second Kiddyland was added later. Some games were just for young patrons such as the Fish Pond, Shirley Temple, and Mickey Moose booths. (Courtesy of Riverview Archives.)

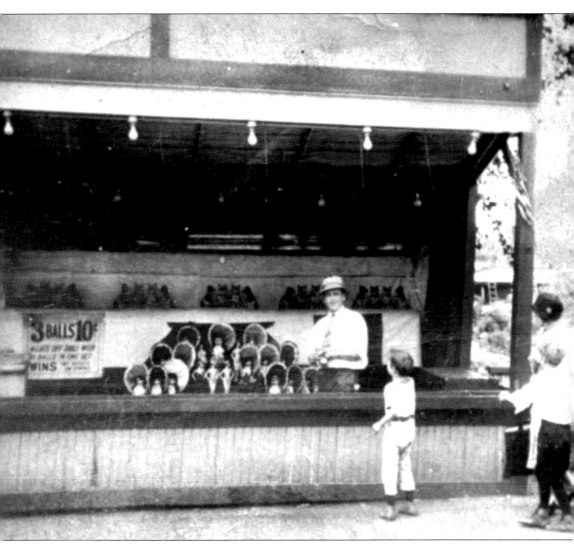

Listening to what the public wanted, the Riverview Company expanded in 1910 adding many and varied games of chance. The Hoopla, rabbit races, monkey races, a race horse game, penny arcades (later nickel, then quarter arcades), and greyhound races all flourished. Games were "difficult" to win but every winner received a prize. This is a display of the original Kewpie dolls. Step right up—try your luck—3 balls for 10 cents. At the cane game if your hoop circled a cane—the cane was yours. (Courtesy of Jeske Collection.)

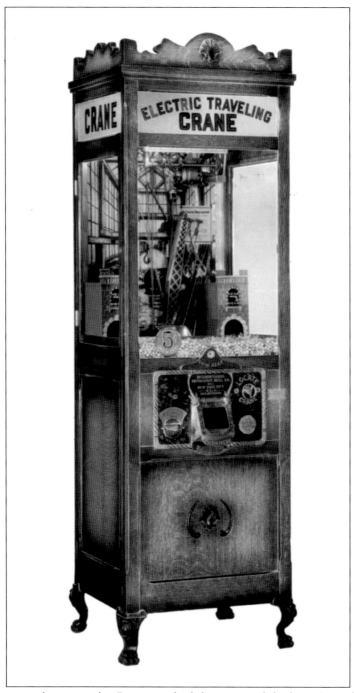

Penny arcades were always popular. Riverview had the most and the best. One of the machines that always attracted customers was the "Crane." What fun and anticipation as the claw dropped over an expensive prize! Carefully the claw was closed and the crane brought the prize to the exit drop—then it was yours but—oops—the prize would slip out of the claw at the last minute. Such disappointment! Oh well, put in another coin and try again! (Courtesy of Riverview Archives.)

Three

PROGRESSING IN THE 1920S

It was "23 Skiddo" and "All That Jazz" in the 1920s. It marked a new beginning at Riverview. From 1914 through World War I Riverview was still attracting crowds, though German Americans were suffering from prejudice. Profits were lower due to this and the dawn of the Great Depression.

There was personal loss. George's parents died. George became president and was named "Mr. Riverview."

Something extraordinary was needed to keep up public interest in the park. The Schmidts bought the Bobs at a cost of $84,000. This roller coaster became the mainstay of Riverview. It is well remembered by everyone who was brave enough to ride it. If it rained, the line at the Bobs determined when the park closed.

For the less brave the Caterpillar was installed. Both of these rides remained popular throughout the life of the park. Other attractions were added including more roller coasters and a 150-foot Ferris wheel.

With prohibition, the customary and profitable beer gardens were threatened. Having a long-time relationship with Chicago Mayor William Thompson may have "saved the day." Raids by federal agents were not held on Sundays, when the largest crowds attended.

"Big Bill" aided park attendance with his Kid's Day and the building of his boat. The boat was built at Riverview with a masthead of Big Bill.

Chicago was gearing up for its 1933 World's Fair. Riverview management was aware of the exhibitions and large Midway planned by leading corporations. It was a severe threat to Riverview for surely everyone would want to go to the fair. How could Riverview survive? It did with its two cent days and five cent nights!

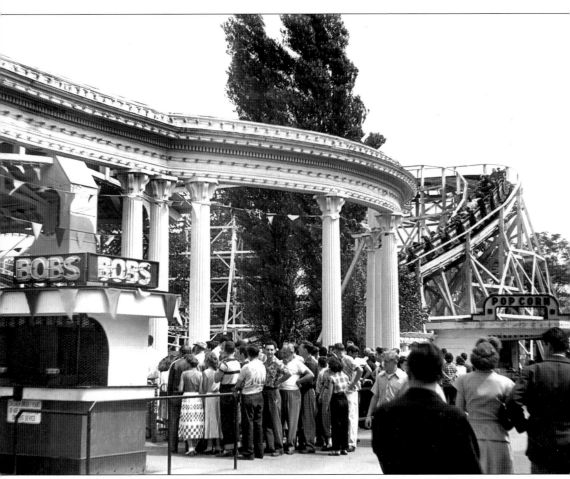

The Bobs—what a ride! The huge white pillars beckoned only the brave. The backseat gave the roughest ride but the front seat let passengers see the steep dips and curves as they approached. Either way, it was fun and safe. The rides were all inspected daily by ride managers. City inspectors plus others from insurance companies came every spring. The Bobs cars were loaded with sand bags weighing up to 6,600 pounds for the test. The president of Riverview personally rode all rides as a final test before the park opened. (Courtesy of Jeske Collection.)

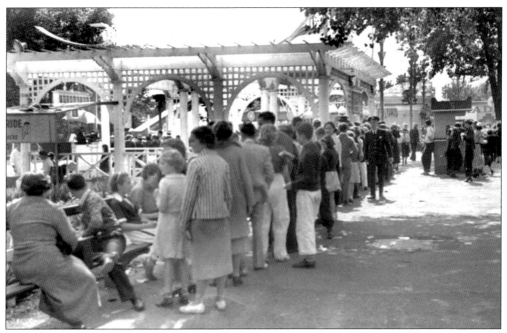

The pillars and entrance to the Bobs were built in 1921 at a cost of $16,000. They were replaced in 1963. Crowds shown here show how popular the ride was. (Courtesy of Riverview Archives.)

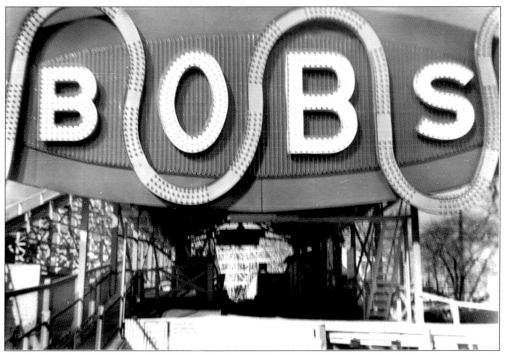

A huge neon sign replaced the entrance. The Bobs was the most popular ride in the park. In one season, 700,000 people rode the ride with 300,000 more taking second rides. There were three million rides taken up until the park closed. (Courtesy of Jeske Collection.)

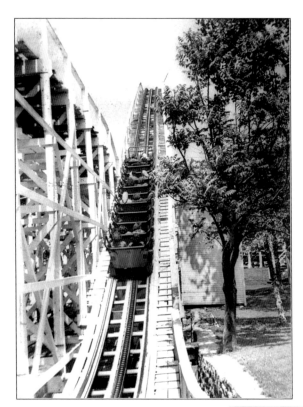

Loaded car No. 1 begins the ride on the Bobs. Speed was an illusion—it was the suspense of the long ride to the top of the first 85-foot hill. Then after a slight pause, plunging down the steep incline and hitting the curve made riders scream. (Courtesy of Jeske Collection.)

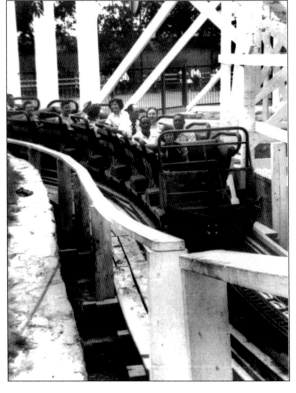

Once gravity took over, passengers felt certain they were going 75 miles per hour; not so—roller coaster experts state the Bobs went 24 miles per hour in the curves and 38 miles per hour in the dips. (Courtesy of Jeske Collection.)

To heighten the illusion of speed, railings were placed close to the ride. A feeling of imminent collision and death made the ride more exciting. The two fatalities on the Bobs at Riverview were due to passengers ignoring danger signs and safety rules. (Courtesy of Jeske Collection.)

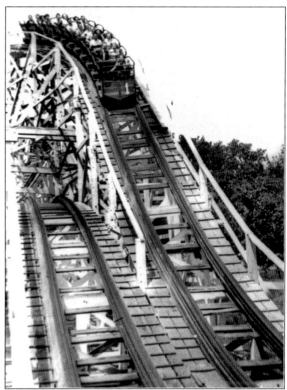

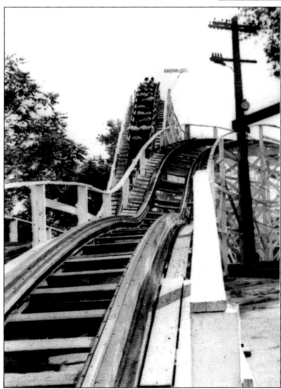

Having structures close to the ride also enhances the feeling of danger and speed. The ride itself doubled back through other structures as seen here. (Courtesy of Jeske Collection.)

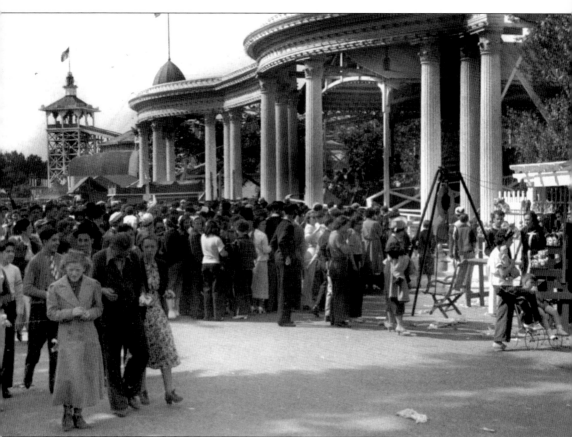

The Bobs' outstanding record of safety was established when Bill Schmidt and his father perfected an electro-pneumatic automatic safety control. One man operated a panel, which controlled all cars at all times. Fail safe equipment went into action if the operator became unable to control the panel. This system revolutionized roller coaster safety and is still in use today. Riverview was awarded the low accident rating of 0.637 for each 100,000 riders by the National Safety Council. Walt Disney checked the safety of his rides with Bill Schmidt before he opened Disneyland in California. The Guess Your Weight Scale is on the far right—another Riverview favorite. (Courtesy of Jeske Collection.)

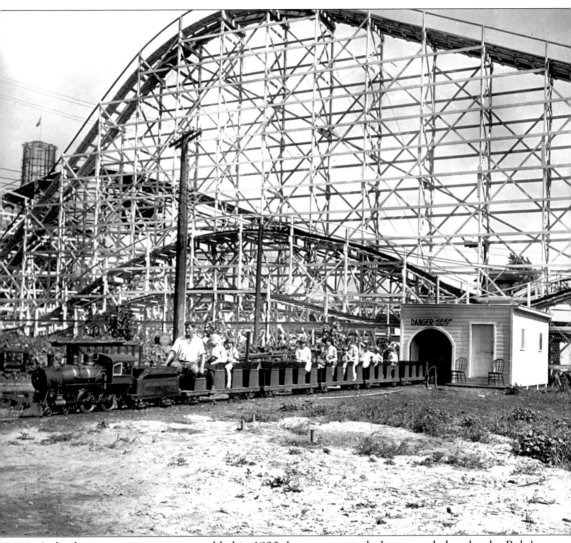

A third steam engine train was added in 1920. It was on a track that tunneled under the Bobs' structure. The trains were popular and continued to run carrying passengers throughout the park until streamliners replaced them in the 1930s. The "B" shaped Midway was along the way and "walking the park" was a two-mile hike. (Courtesy of Riverview Archives.)

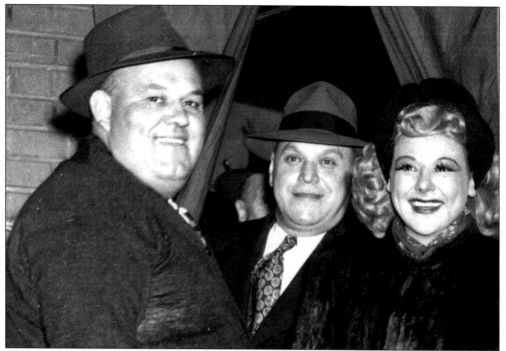

Carl Jeske ran the Bobs for 20 years and loved the ride. He walked it twice a day, loaded sand bags for safety tests, and then rode the cars himself. One of his special moments as ride manager was meeting movie star and ice skating champion, Sonja Henie. (The center person is unidentified.) (Courtesy of Jeske Collection.)

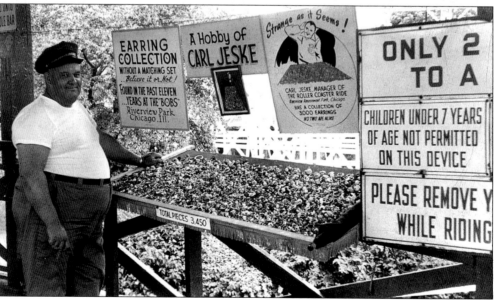

Carl's other claim to fame was his single earring collection featured in the "Strange as it Seems" newspaper column. On the last curve passengers were tossed around so violently that wallets, coins, earrings, and even false teeth were lost. His crew split the money—Carl kept the earrings. (Courtesy of Jeske Collection.)

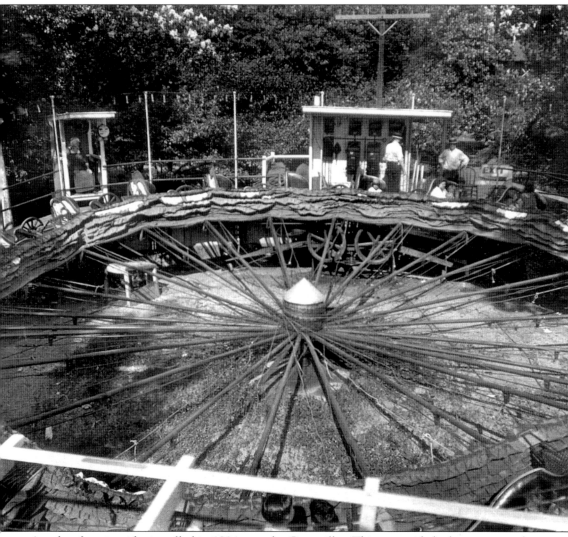

Another favorite ride, installed in 1924, was the Caterpillar. This tame ride had cars mounted in a 60-foot circle. When the cars were in motion a canvas covered the entire ride. It was a dark ride—another opportunity to steal a kiss. The Caterpillar "crawled" right up until the park closed.(Courtesy of Riverview Archives.)

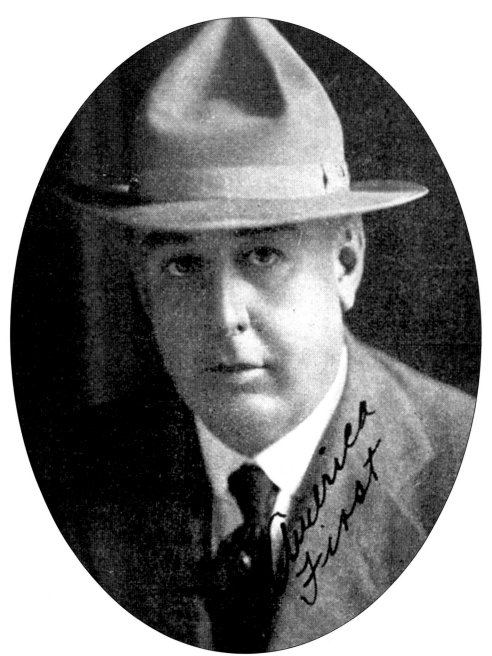

William Hale Thompson, known to his friends as "Big Bill," was Mayor of Chicago and a good friend of George Schmidt. Every year the Mayor closed the schools for a day and paid for student carfare, admission, and for rides at Riverview. He distributed thousands of copies of the Constitution and other educational information to the children. Kid's Day was a special treat as money, even pennies, was scarce during the Depression. A group of women halted the day-long program, but Charlie Weber, a local ward alderman, kept the day alive till he died in the 1960s. In order to keep his image before the public, "Big Bill" built a boat at Riverview. The idea was to take a South Sea cruise to find fish that climbed trees. However, the voyage ended in New Orleans and the fish were never found. (Courtesy of Riverview Archives.)

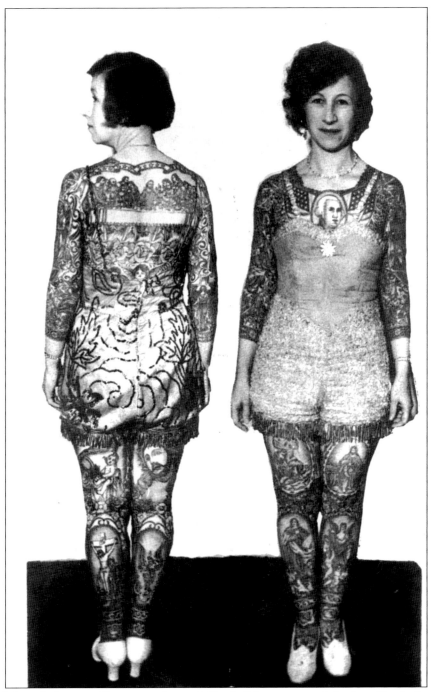

One of the sideshows at Riverview featured "freaks." It was one of the best "freak shows" in the country. People who participated in the shows were offered an opportunity to make a livelihood and often not only supported themselves but contributed to their families. Pictured is the "Tattooed Lady." Sword swallowers, magicians, and contortionists were part of the show. (Courtesy of Cleary Collection.)

The 1920s brought many sad and anxious moments to the Schmidt family, including the death of George's parents. Despite this, people kept trying to be happy. Mardi Gras was greeted as a relief from the Great Depression but attendance at the park decreased drastically. Riverview employees worked at half salary—George worked for $1 a year for three years. The 1933 World's Fair was being planned and loomed as a threat to Riverview. Management solved the problem of keeping customers by initiating two cent days and five cent nights. (Courtesy of Agnes Smith Collection.)

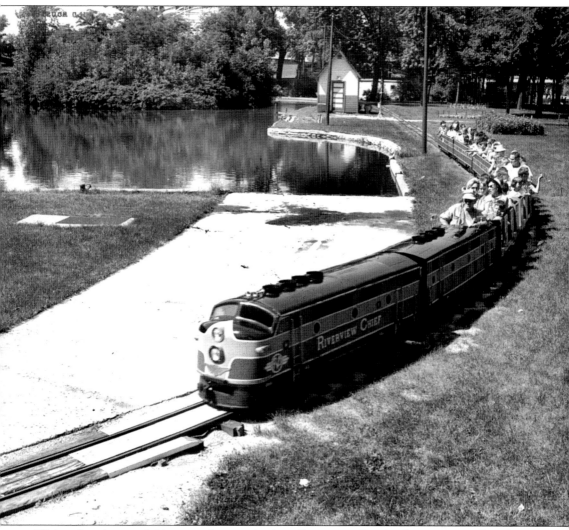

With reduced cost of rides, people came back to Riverview. On the first two-cent day, there was a profit of $8,000. Loyal employees were repaid and attractions increased. In 1921, the Blue Streak, Zepher, and Pippin roller coasters were added. Rides were "streamlined." Coaster cars were enclosed in bright metal covers. New names were given to old rides such as the Royal Gorge, Big Dipper, and Jack Rabbit. The trains too were replaced with two diesel streamliners called the "Chief" (shown) and the "Scout." (Courtesy of Schmidt Collection.)

An established favorite since 1910, the roller rink, continued to attract customers. Russ Young, at the organ, played songs from each decade. In the 1920s it was "Yes, We Have No Bananas," "Barney Google," "Running Wild," and "Who's Sorry Now?" The dance hall was enlarged. More people came to Riverview. Change in music kept them skating and dancing for years. (Courtesy of Jeske Collection.)

Picnics were as popular as ever. Large corporations such as Crane and Ford would "buy the park" for an entire day. Others would buy admission and ride tickets for their employees for a day. The United Charities held its Riverview Rambles at the park for 12 years, raising thousands of dollars for its philanthropic projects. No matter how large the crowd (Ford had 50,000 employees) attendance never matched the 217,000 who attended in 1908 to hear Senator James Hamilton Lewis. It is only fair to mention that automatic counters did not come into use until 1909. (Courtesy of Riverview Archives.)

WW I brought many very unpleasant times to German-Americans as prejudice ran high. However, the park grew. Park owners and concessionaires belonged to the National Outdoor Showman's League formed in 1917. Since most members were in the amusement park business, in 1920 they organized the National Association of Amusement Parks. By 1967 it was an international association. George Schmidt was a founding member, treasurer, and president. His son, Bill, also served as president. It was through this association that rides could be tested in parks, recording public approval, and new concessions introduced. (Courtesy of Riverview Archives.)

Four

THE STREAMLINED 1930S

Attendance dropped and kept dropping. George had turned in his stocks but because of the stock market crash they were not as valuable as when purchased. The bank refused a loan. Riverview was in debt. Loyal employees worked at half wages, George for $1 a year for three years.

Then at a board meeting the idea of low cost rides and entrance fees was discussed. One park had tried it but would it work at Riverview? Yes! It worked. The two cent days and five cent nights saved Riverview.

People flocked to the park. The rides were two cents, admission only five cents every night. At the end of the first two cent day there was a profit of $8,000. Everything in the park was two cents. Hot dogs were served on special two-inch buns. Lemonade cups and ice cream cones were smaller, but they sold. They sold enough to save the park. Employees were repaid and thanked, George looked happy again.

Riverview invented its only original ride—the Pair-O-Chutes. Utilizing the steel 220-foot Eyeful Tower, arms were added and bosun seats carried passengers up 180 feet, there was a pause, and then they floated down. There was no "free fall"; it just felt like it.

The ride was not a big money-maker as only eight passengers could take the trips at one time. But it paid off in publicity. It was copied at the 1939 New York World's Fair and became a prototype for training paratroopers in World War II. There was no greater challenge than riding the Pair-O-Chutes.

Forty acres of land was sold to the Chicago Board of Education for construction of Lane Technical High School. The property was located at Addison Street and Western Avenue. The park now covered 70 acres.

Riverview purchased several rides and attractions, including 300 Banjo lights, when the World's Fair closed. A second Kiddyland opened. The Bug House that had burned down earlier was replaced with Aladdin's Castle. The park was updated.

By the end of the 1930s, war was brewing in Europe. America entered the war December 7, 1941.

Albert Gibbney, an Irish immigrant, came to Chicago alone. The rides at Riverview fascinated him and as a hobby he created them in miniature, to scale. Being an engineer he made all the rides operational. These rides became an integral part of the United Charities fundraising promotion at Riverview. A party was held annually at the Ambassador East Hotel announcing the Riverview Rambles. This photo shows three of the 11 rides recreated by Albert Gibbney. Fran Allison (of television's *Kukla, Fran, and Ollie*) and Bill Schmidt admire the display. (Courtesy of Riverview Archives.)

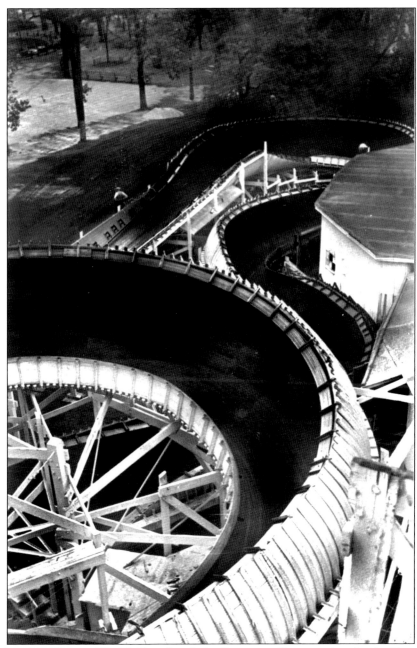

When the 1933 Chicago World's Fair closed, the Riverview Company bought the Flying Turns. This ride brought passengers up an incline. Gravity took over and riders and cars were plastered against the half circle tubes by centrifugal force. The ride's safety was difficult to maintain. A wooden reinforcement was placed on the outside of the ride to keep it from collapsing under the stress. The following were also purchased: scooters, a rocket ship, the Streets of Paris show, a captured dive bomber, a marine exhibit complete with whale, the Hall of Statues, and 300 banjo lights. In 1935, the 140-acre park was remodeled at a cost of $250,000 using "200 building artisans and landscapers." It was billed as "Chicago's Permanent World's Fair." (Courtesy of Riverview Archives.)

Though food items were still given at the Stop and Shop booth, larger prizes were also offered. In 1936, a man won a Ford touring car. Two other lucky winners won pianos. (Courtesy of Riverview Archives.)

Game prizes changed too. People no longer wanted Kewpie dolls. Stuffed animals, other dolls, and statuettes were given away. The number of prizes increased as the games became more and more popular. (Courtesy of Riverview Archives.)

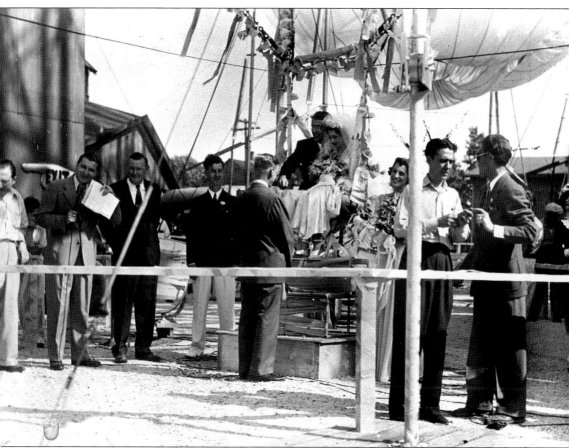

The Schmidts designed and built a half dozen rides and made improvements on others. In 1937, their Pair-O-Chutes ride was created. They utilized the steel Eyeful Tower built in 1910, added arms at the top and suspended parachutes for fun—they were actually "window dressing." The tower was 220 feet high including the 10-foot flag pole. Riders ascended 180 feet. Release of the bosuns seats holding riders was fully operator controlled. One couple chose to be married on the ride; the publicity was welcomed. The ride was copied for the New York World's Fair in 1939 and was a prototype for training paratroopers in World War II. (Courtesy of Jeske Collection.)

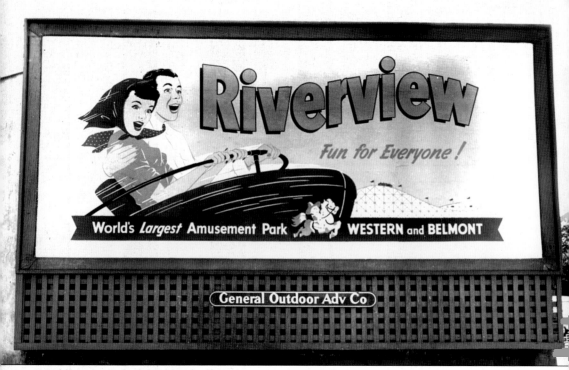

Publicity was the life's blood of Riverview as the park had to succeed from May to September. Advertising was a priority expense. In 1904, $10,000 was spent, by 1967, $300,000. People knew what was new at the park through billboards, radio, television, and newspapers. A billboard was already announcing the 1968 season when the park closed. Riverview was a favorite topic for newspaper writers including: Mike Royko, Len O'Connor, Clifton Utley, Fahey Flynn, Bob Elston, Jack Brickhouse, and many others. By 1953, 65 television and radio shows mentioned Riverview. (Courtesy of Riverview Archives.)

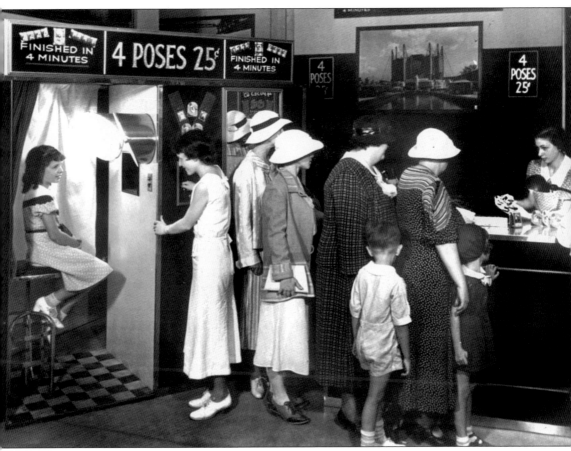

The Coultry photo service was still one of the most successful concessions at Riverview. The poses were still four for 25 cents but it took four minutes instead of one to deliver. Undoubtedly this was due to the larger number of customers. Prices increased to $3 later, but people still loved posing on the moon. (Courtesy of Coultry Collection.).

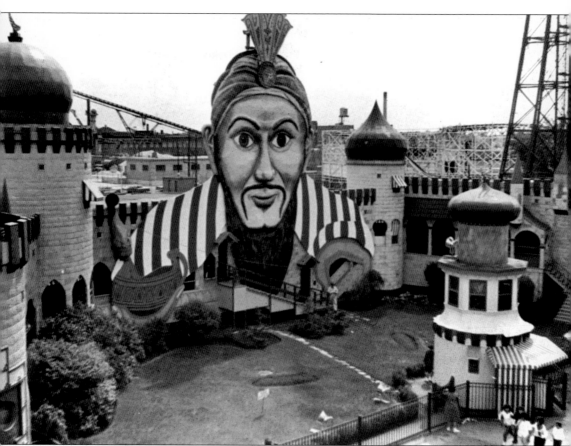

Early in 1930, the Bug House burned completely. Since the Mardi Gras floats were stored there, the parade had to be cancelled. A new bigger building was designed by Marion Macdonald. The huge head of Aladdin had rolling eyes. The mirrors, barrel roll, and air holes were repeated. The slide was eliminated. The new castle did not attract as many patrons as the Bug House. Customers were changing—it was speed that captured them. (Courtesy of Jeske Collection.)

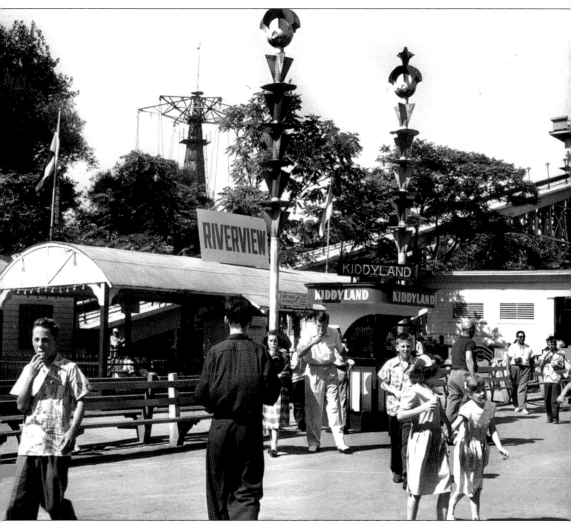

More and more children were going to Riverview. The management installed a second Kiddyland with more rides scaled to the youngsters' size. The Whip, Merry-Go-Round, and Ferris wheel in miniature made kids feel grown up: they could ride alone. Fireworks lit up the sky every Fourth of July. There was always fun for everyone, regardless of age. (Courtesy of Riverview Archives.)

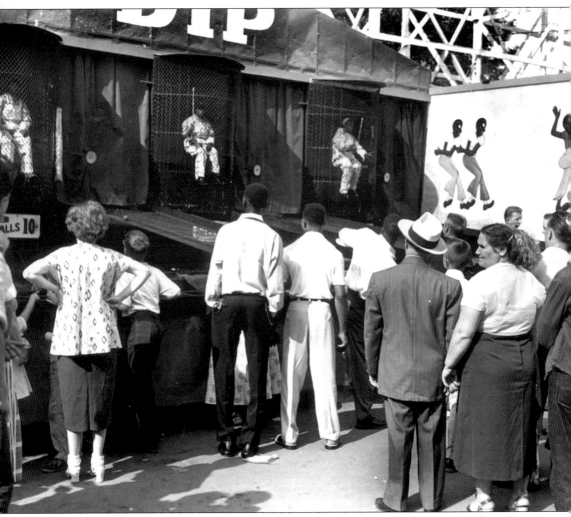

One attraction that was a part of Riverview history since 1908 was the Dips. Originally a clown sat on a board over a tank of water. A target, when hit with a ball, released the seat and dipped the clown. Later African Americans were hired, at a higher rate of pay, to sit in the Dips. The game was eliminated before the park closed. African Americans held their annual Bud Billeken parade, honoring the mythical godfather of Chicago black children, at Riverview. It is now held in downtown Chicago. (Courtesy of Carlstedt Collection.)

Five

OVER AND OUT

Though new rides, shows, and attractions continued at Riverview, times were changing again. The former thrill of the Figure 8 bumping along at 6 miles per hour was not acceptable. Speed was demanded.

The Scenic Railway was replaced with faster roller coasters: the Derby, Pippin, and Greyhound. Even the Bobs had competition when the Fireball was invented in 1959.

Servicemen and women were returning home from World War II and were not impressed by the Pair-O-Chute jump. Many had been dropped behind enemy lines and the ride was a reminder of a time best forgotten.

New rides were more costly. Nearly $300,000 was paid for the Sky Ride, which merely provided a view of the city, now available free of charge from the tops of some Chicago skyscrapers.

The Riverview Company operated on a five-year projection plan. In 1960, theme parks were drawing families away from the smaller parks. Other Chicago amusement parks had already closed.

Maintenance wages were $11 per hour for park employees with a projected future increase to $25 per hour. Only union workers were employed at Riverview. An estimated $1 million was needed for park repair in 1968.

The neighborhoods were changing and crowds needed more police security. The park's police force now numbered 34.

An offer was made by the Arvey Corporation to buy the property. The board of directors carefully reviewed the park's future. They decided to sell, outvoting President Bill Schmidt. The transaction was held in secret as other bids had been made in the past but failed to have the needed financial backing. The final papers were signed October 3, 1967.

There was complete shock and disbelief by employees and the public when newspapers, radio, and television newscasters made the announcement. Letters pleading for the park, some threatening, were sent to Riverview but to no avail; newspapers printed nostalgic letters. Requiem columns were written.

The rides were auctioned. Bulldozers and a demolition ball crashed through the familiar structures. Employees wept. Sale of the rides did not yield the anticipated profits. Some rides were dismantled and parts sold separately.

Soon the land was bare. A few tattered red and blue banners in the mud and the grove trees bore witness that the park had ever existed. No more would the invitation "Let's Go to Riverview" be heard.

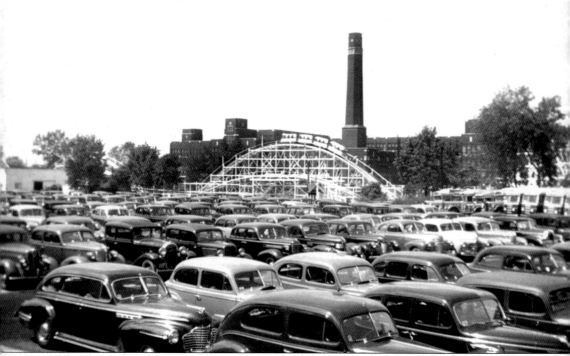

During the 1930s, the Riverview Company sold a portion of its property to the Chicago Board of Education for construction of Lane Technical High School. The school was built at Addison Street and Western Avenue. By the 1940s, World War II military personnel were admitted to the park free of charge with reduced cost of rides. By the look of this photo, parking lots were full. The Silver Flash, with its cars streamlined with metal covers, and Lane Tech are in the background. (Courtesy of Jeske Collection.)

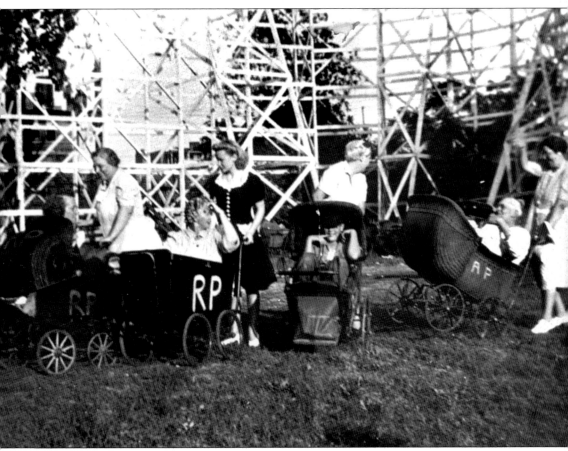

A necessary addition was made to the park—100 baby buggies. Rental fee was 50 cents for three hours with a refundable deposit of 50 cents on return. There were only 30 strollers originally. I can remember being pushed in one of those green, wooden strollers. It was not comfortable as there was no padding. (Courtesy of Jeske Collection.)

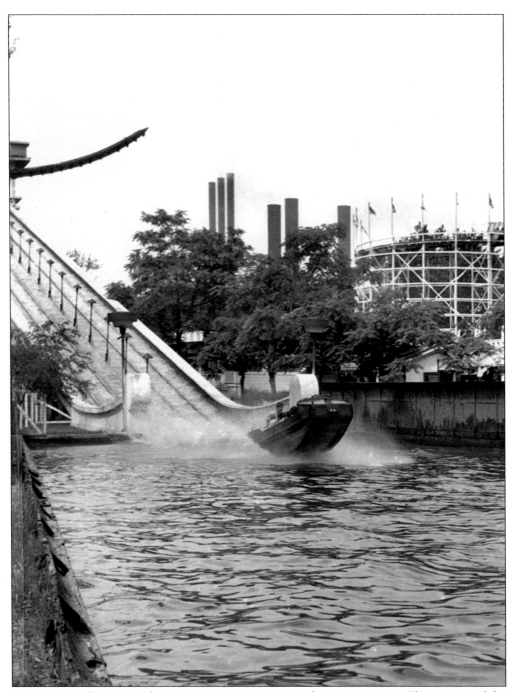

In 1951, complimentary photos were given to promote the picnic groves. This picture of the Chutes clearly shows the double slide runner and new modern lights. The boat bounces in the lagoon. The high structure on the right is the Comet. When the park closed, the Chutes was the only one of its kind still in operation. It boasted two million riders in six decades. (Courtesy of Jeske Collection.)

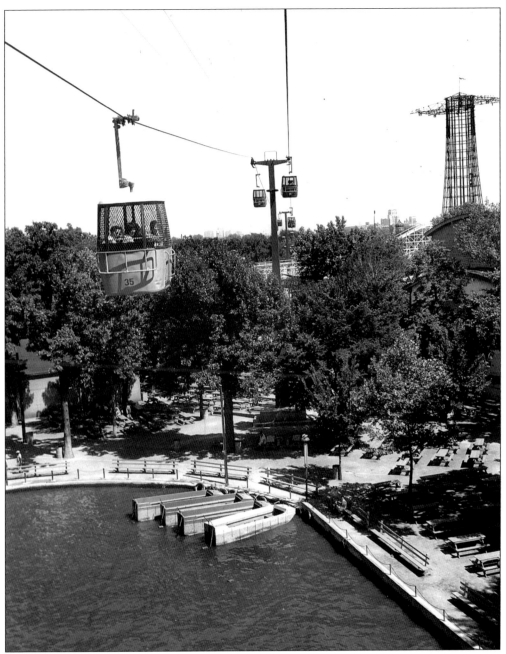

In 1957, George Schmidt died. His son, Bill, a graduate of Illinois Technical Institute with degrees in mechanical and electrical engineering, became president of Riverview. In 1959, he invented a new ride—the "Fireball." It cost nearly half a million dollars. The actual ride lasted only 1 minute, 50 seconds. Behind the scenes there was a feeling of trouble ahead. Times were changing again. People were moving to the suburbs. Television was keeping them at home. Riverview celebrated its 50th and 60th anniversaries reaching its attendance goal of two million. Rides were becoming more expensive. The Sky Ride, imported from Switzerland, cost $275,000. Recovery of these investments would take years of operation. (Courtesy of Jeske Collection.)

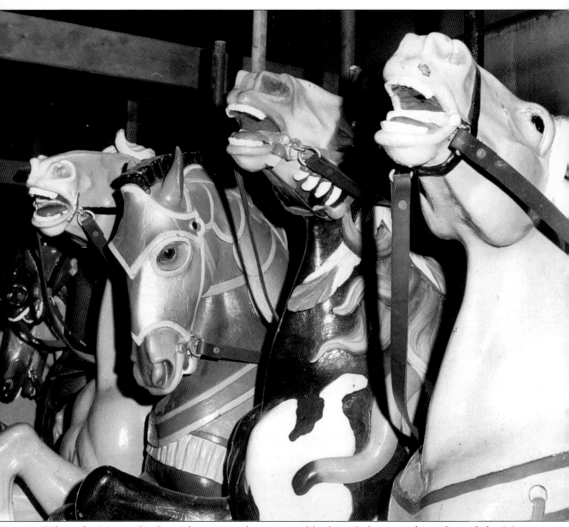

When the Merry-Go-Round went on the auction block, a Galena resident phoned the Mayor and encouraged him to buy the ride as it was an outstanding example of American folk art. He planned to open a park using the carousel as the feature attraction. The ride had been restored earlier that year for $1 million. The complete machine was sold for $40,000 with shipping charges of $25,000. Everything was stored for years. The people of Galena preferred a mall to a park. The complete ride was sold to Six Flags Over Georgia, Atlanta where it continues on its circular path to nowhere. (Photo by Dolores Haugh.)

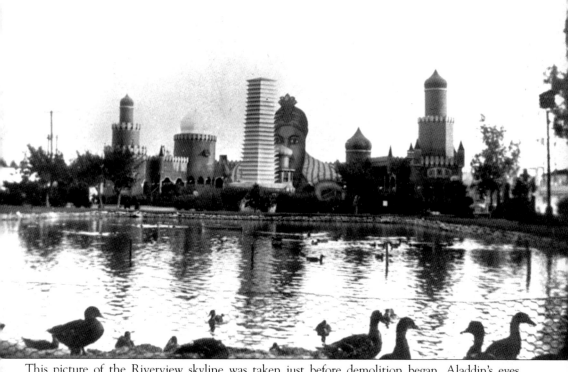

This picture of the Riverview skyline was taken just before demolition began. Aladdin's eyes were forever stilled. The surrounding buildings were torn down first—Aladdin's head last. The permanent resident ducks seem oblivious to the park's demise but soon they too disappeared. Demolition of the roller coasters and Chutes structures were a surprise. They were not rotted and had to be smashed with a demolition ball. All wood in these hand built structures had been treated for preservation. The Pair-O-Chutes came down in one piece. (Courtesy of Jeske Collection.)

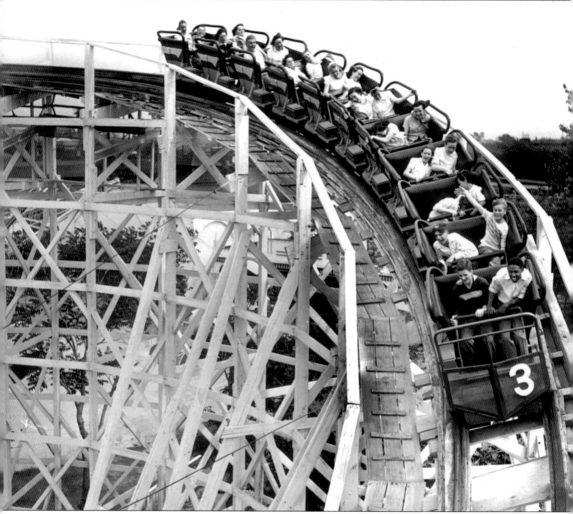

Carl Jeske was one of the employees who wept. He saw the ride he had cared for being torn down. "I couldn't believe Riverview would not open in 1968, but it was true," he said. The hardest part was saying goodbye to "his boys." These were young men hired each year to work on the Bobs. "They were like my own sons," he said. This picture was taken the year the park closed. The riders did not suspect it would be their last ride on the Bobs. (Courtesy of Jeske Collection.)

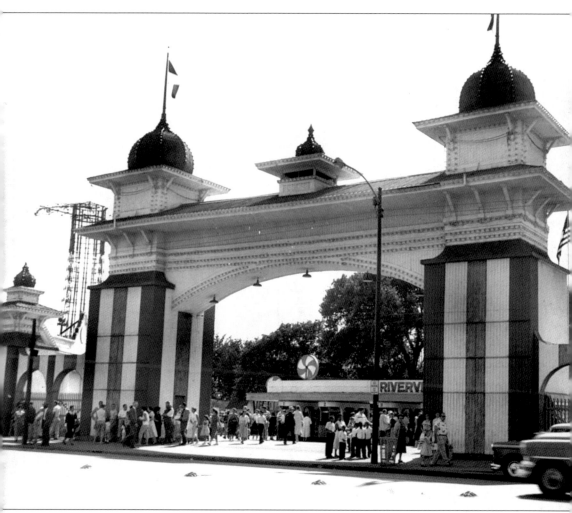

Patrons are leaving Riverview for the last time. The sale was held in strict confidence. Bids had been made on the park in the past, but could not be completed because of insufficient funds. The announcement of the park's unexpected sale had different reactions from the public. Letters, some threatening, were sent to the Riverview board and to the newspapers. Stories were printed expressing disdain, but most recalled fond personal experiences at the park. One newspaper ran a contest for the best memory of Riverview. Thousands responded. Two Ton Baker who sang "Laugh Your Troubles Away" on television stopped singing. The song had ended. (Courtesy of Schmidt Collection.)

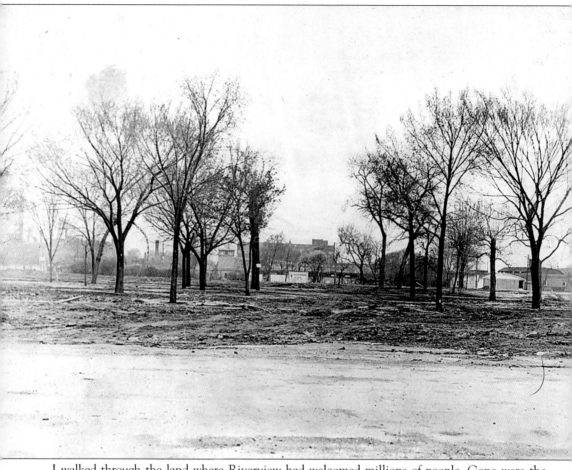

I walked through the land where Riverview had welcomed millions of people. Gone were the 7 roller coasters, high cable ride, 6 airplane-type rides, 3 water rides, Safari thriller, parachute jump, giant Ferris wheel, and 40 other attractions including Aladdin's Castle, 2 Kiddylands, Merry-Go-Round, ghost train, and Tunnel of Love. There was no music or sound of laughter. Gone was the aroma of roasting hot dogs and peanuts. There were no crowds. Only the staunch grove trees stood as witnesses to the existence of the world's largest amusement park—Riverview. (Photo by Dolores Haugh.)